VaN GogH & friends

VaN GogH & friends

With

CÉZANNE, SEURAT, GAUGUIN, ROUSSEAU,

and TOULOUSE-LAUTREC

by Wenda O'Reilly, Ph.D.

with Mariele O'Reilly, Noelle O'Reilly, Ahna O'Reilly, Katherine Kravitz,
Diana Howard and Susana Sosa

BIRDCAGE BOOKS
Palo Alto

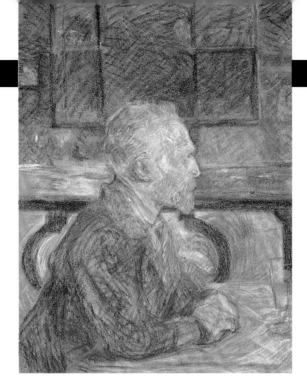

For information, contact Birdcage Books,
2310 Bowdoin Street, Palo Alto, CA 94306.
www.BirdcageBooks.com

Cover and interior design: Diana Howard

Library of Congress Cataloging-in-Publication Data

O'Reilly, Wenda Brewster.
 Van Gogh & friends : with Cézanne, Seurat, Gauguin, Rousseau, and
Toulouse-Lautrec/ Wenda O'Reilly with Mariele O'Reilly... |et al.—1st ed.
 p. cm.
 Includes bibliographical references and index.
 ISBN 1-889613-09-6
 1. Post-impressionism (Art)—France. 2. Painting, French—19th century.
3. Painting, French—20th century. I. Title: Van Gogh and Friends. II. O'Reilly,
Mariele, 1988- III. Title.
ND547.5.P6 O74 2002
759.4'09'034—dc21 2002074373

Distributed by Publishers Group West
1700 Fourth Street, Berkeley, CA 94710 USA • (800) 788-3123

FIRST EDITION

2 4 6 8 10 9 7 5 3 1

PRINTED IN HONG KONG

My heartfelt thanks to Mariele, Noelle and
Ahna O'Reilly and to Katherine Kravitz for their
superb editorial assistance. They worked after school
and on weekends, helping to select the artists and works
of art to be included and reviewing and editing each
paragraph of the book.

Special thanks to Diana Howard
for her creative vision and whole-hearted involvement
in every aspect of the project, and to Susan Sosa for her
excellent art history research. And many thanks to
Victoria Alden, Susan Brady, Barbara Greiner-Bouffé,
Charles Hanson, Krista Holmstrom,
Seymour and Fernande Howard, Sean O'Reilly,
Suzanne Park, Palmer and Dorothy Smith,
Vanessa Topper, and George Wright for their
assistance, expertise and encouragement.

My young assistant editors and I would like
to express our appreciation to the many people at
museums around the world who have kindly
offered their help and advice.

Finally, we would like to give very special thanks
to James O'Reilly, Harriet Bullitt and Erin,
Maureen and Kerry Kravitz for their many fun ideas,
enthusiasm, love and support.

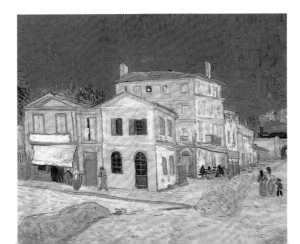

Table of Contents

*I*n 1886, Vincent Van Gogh left his home in Holland and traveled to Paris. There he found a world and way of living that was like nowhere else. Paris was filled with theaters, dance halls, cafés, large boulevards for strolling, and parks filled with people at leisure. The city was alive day and night. In Paris, Van Gogh met other young artists — Georges Seurat, Paul Gauguin and Henri de Toulouse-Lautrec — and, for the first time, he saw the paintings of the Impressionist artists.

La Belle Époque

Van Gogh and his fellow artists painted in a period known as the Belle Époque, "the beautiful age." It was a flamboyant and carefree period that began in the "gay nineties" and ended with the outbreak of the First World War. Tremendous wealth had been created by the Industrial Revolution and the colonization of countries around the world by the newly industrialized nations. That new wealth was on display in Paris. Elegantly dressed ladies and gentlemen strolled the boulevards and rode about town in magnificent carriages. Their evenings were spent at the opera, ballet and theater or at circuses and nightclubs. For the rich, much of life was a party.

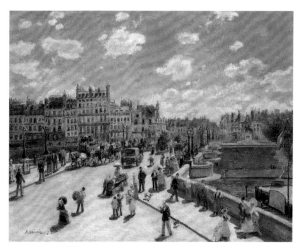

THE PONT NEUF, PARIS Auguste Renoir, 1875
In this Impressionist painting, Renoir depicts Paris in the late 1800's. The Pont Neuf is one of more than twenty bridges that cross the Seine River as it flows through the center of the city.

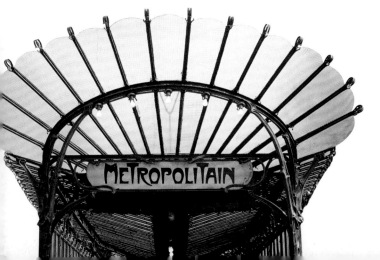

PARIS SUBWAY ENTRANCE, 1900
A new style of art and architecture appeared in Paris during the Belle Époque. Art Nouveau (meaning "new art" in French) had curving lines and designs with vines, flowers, birds, shells and other shapes from nature. Art Nouveau designs graced everything from household furniture and Tiffany lamps to advertising posters and the new Paris subway stations.

Age of optimism

The spirit of the Belle Époque was on display in two Paris world's fairs, one held in 1889 to celebrate the 100th anniversary of the French Revolution, and the other held in 1900 to usher in the new century. Opening the fair in 1900, the French prime minister said, "The forces of nature are subdued and tamed; steam and electricity have become our obedient servants; the machine is crowned queen of the world….Science serves us ever more diligently and is conquering ignorance and poverty." His words expressed the great optimism and the faith in science and technology with which the 20th century began.

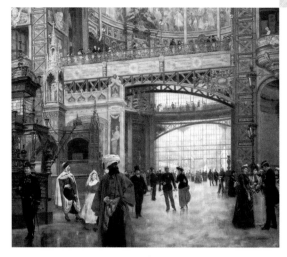

MACHINERY HALL AT THE 1889 ÉXPOSITION Louis Beroud, 1889
This painting of a popular exhibit hall captures the grandeur and international flavor of the two Paris world's fairs. Visitors came from all over the globe to see thousands of exhibits of new machines, scientific advances, and arts and crafts from around the world.

EIFFEL TOWER AND FAIRGROUNDS
When Gustave Eiffel designed his tower for the 1889 world's fair, he included a research station at the top where he could conduct weather experiments. Thomas Edison visited Eiffel there. The two men shared their ideas and visions of a world transformed by new inventions and scientific discoveries.

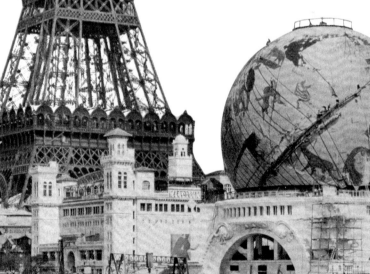

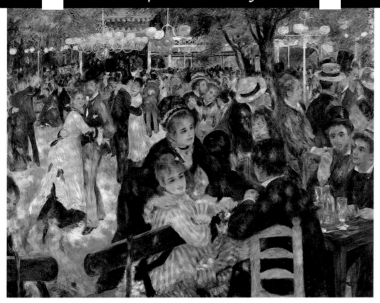

DANCING AT THE MOULIN DE LA GALETTE Auguste Renoir, 1876
Impressionist artist Auguste Renoir painted his friends dancing and having a good time.
They are bathed in dappled sunlight that filters through the trees.

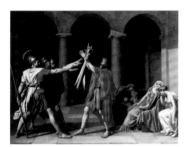

THE OATH OF THE HORATII
Jacques-Louis David, 1784
The Impressionists rebelled against grand
paintings like this one of Roman soldiers
preparing for war. The father of the Horatius
family is making his three sons take an oath.
They are swearing that they will conquer in
battle or die. The women are weeping for
loved ones fighting on both sides.

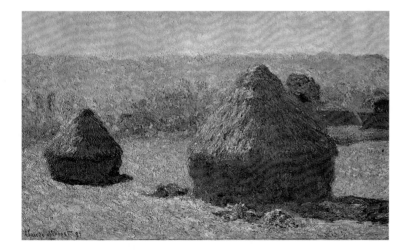

The Impressionists

In the 1870's, a small group of
artists, called Impressionists,
started an art revolution with
their new style of painting.
Their art celebrated everyday
life in vibrant colors. Before
the Impressionists, most
European art depicted grand
and dramatic scenes from
history, myth, and religion.
Artists painted everything in
sharp detail with brushstrokes
that were hardly visible and
colors that were subdued.
Instead, the Impressionists
depicted ordinary scenes and
fleeting moments in life.
They painted in bigger, visible
brushstrokes and used lighter,
brighter colors. They especially
wanted to show the effects of
light flickering and reflecting
on people and things. Their
daring new style inspired a
group of young artists who
came to be known as the
Post-Impressionists.

GRAIN STACKS, END OF SUMMER
Claude Monet, 1891
Impressionist artist Claude Monet made a
series of grain stack paintings at different
times of day and in different seasons. He
wanted to show how their appearance
changed in different kinds of light.

Search for deeper meaning

The Post-Impressionists were inspired by the Impressionist artists, but each of them wanted to go beyond the depiction of fleeting moments in life. Some of them wanted to paint scenes with a sense of permanence, others wanted to make their art more scientific, and all of them wanted to create images with deeper meaning.

The Impressionists usually painted people with expressions that did not show their inner thoughts and feelings. Most of the Post-Impressionists wanted to paint people in a way that revealed their character or made a comment about society. Some of the Post-Impressionist artists believed that colors and patterns, all by themselves, expressed different feelings and moods, and they used various symbols in their art to convey deeper meaning.

A sense of permanence

Several Post-Impressionists wanted to give a sense of timeless permanence to their art. They wanted to paint everyday scenes but imbue them with a classic order and solidity found in much older styles of art from ancient Egypt, ancient Greece and the Renaissance.

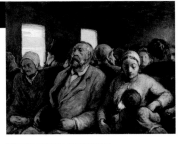

THIRD CLASS CARRIAGE
Honoré Daumier, 1862
Van Gogh and Lautrec, who painted scenes of the poor, were inspired by the art of Honoré Daumier. He was one of the first artists to depict the plight of the poor in Industrialized Europe. Here, he conveys both their misery and their dignity.

Science in art

In the 1800's, scientists made many discoveries about light and its spectrum of colors. The Post-Impressionists were among the first artists in history to apply scientific laws of light and color to their art.

For centuries, paints were made from things like ground-up beetles, burnt bones, different kinds of metal, and even precious stones. Some of the colors were bright, but many were muted and dull. In the 1800's, chemists found ways to produce many new and vibrant colors in their laboratories. The Impressionists and Post-Impressionists were the first artists to use these bright, new pigments.

They used the discoveries of physicists and chemists in choosing which colors to place side by side to create various artistic effects.

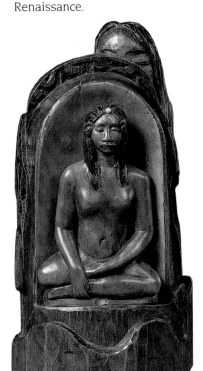

IDOL WITH A PEARL Paul Gauguin, 1892
Paul Gauguin liked to combine symbols from different religious traditions. He carved this idol as a Polynesian, but she is seated in a Buddha-like position. The pearl on her forehead represents the third eye, or inner vision, that is part of the Buddhist religion.

In the same 30-year period that Van Gogh and friends painted their greatest works, Impressionist artists were also creating masterpieces, and younger artists were developing new art styles.

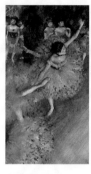

GREEN DANCER
Edgar Degas, 1880

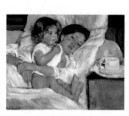

BREAKFAST IN BED
Mary Cassatt, 1881

PEASANTS PLANTING PEA STICKS
Camille Pissarro, 1890

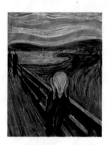

THE SCREAM
Edvard Munch, 1891

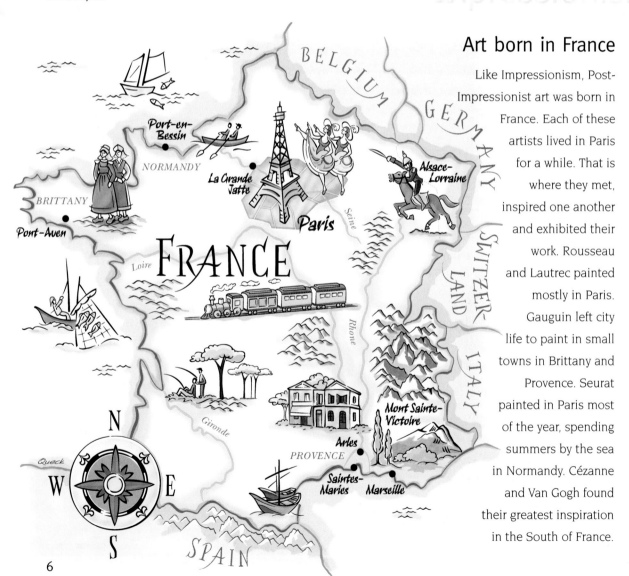

Art born in France

Like Impressionism, Post-Impressionist art was born in France. Each of these artists lived in Paris for a while. That is where they met, inspired one another and exhibited their work. Rousseau and Lautrec painted mostly in Paris. Gauguin left city life to paint in small towns in Brittany and Provence. Seurat painted in Paris most of the year, spending summers by the sea in Normandy. Cézanne and Van Gogh found their greatest inspiration in the South of France.

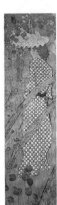

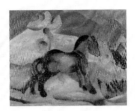

THE KISS
Gustav Klimt, 1907

LITTLE BLUE HORSE
Franz Marc, 1908

RED ROOM
Henri Matisse, 1908

**STILL LIFE WITH
CHAIR CANING**
Pablo Picasso, 1912

WOMAN IN A CHECKED DRESS, Pierre Bonnard, 1891

Rapid change

Throughout history, for century upon century, people's ways of living changed slowly from one generation to the next. The Industrial Revolution brought rapid change for the first time in history. In the space of a few decades, millions of people moved from farms to cities, drawn by factory jobs. Millions more left Europe for America.

Goods that had been made by hand for centuries were now mass produced by machines. The industrialized nations competed to control and colonize underdeveloped countries around the world. This gave industrialists access to the raw materials they needed for their factories and more places to sell their finished products.

Cars, trains, electric lights, the radio, phonograph and telephone were all invented in the 1800's, completely changing people's everyday lives. New scientific and medical discoveries gave people hope of living longer, safer lives. This was the beginning of modern times, marked by constant and rapid change.

Burst of creativity

When the Impressionists first exhibited their work together in 1874, the public was shocked to see such a new style of art. Ten years later, Impressionist art began to be accepted and admired. The new pioneers were the Post-Impressionist artists, who were being ridiculed in the 1880's. Over the next several years, their art also came to be accepted and admired. In less than thirty years, the Impressionists and Post-Impressionists created the greatest art revolution since the Renaissance.

For hundreds of years, art in France had been rigidly controlled. Artists could only become successful if their paintings were approved by a panel of old-style academic judges and displayed in the official art exhibition, called the *Salon*. Then the Impressionists and the Post-Impressionists developed their fresh new styles of art and exhibited them independently, inspiring younger artists to do the same. The result was a burst of creativity and an explosion of many different styles of art.

1876 Alexander Graham Bell, an inventor and teacher of the deaf, invents the telephone.

1889 George Eastman invents the Kodak camera. It is the first portable and affordable camera, allowing people to take snapshots of their daily lives and their travels.

1870 The Germans defeat the French in the Franco-Prussian War. During the war, Paris is bombarded and under siege. Parisians resort to eating dogs, cats and rats to keep from starving.

1876 Great Britain proclaims Queen Victoria Empress of India. British governors have ruled India since 1857, calling it "the jewel in the crown" due to its riches in tea, spices, cotton and precious jewels.

1884 Labor unions and strikes are legalized by the French government. At last, coal miners and factory workers have the right to fight for better working conditions. Since the beginning of the Industrial Revolution, they have worked at grueling and dangerous jobs for very low pay.

1870's The Japanese embark on rapid industrialization believing that if they do not, they may be overrun by industrialized nations bent on empire building. Western imperial powers have already taken control of large parts of Asia and Africa, and all of India.

1889 The Eiffel Tower is built for the Paris world's fair. It remains the tallest man-made structure in the world until the Empire State Building is built 42 years later.

1870 1875 1880 1885 1890

1874 For the first time, Claude Monet and his friends exhibit their work together, including Monet's *Impression, Sunrise*. A critic who hates their art calls the group "impressionists" as an insult. The name sticks.

1880 Thomas Edison develops the first practical electric light bulb. Electric lights begin to replace gas lamps and oil lanterns.

1886 France gives the Statue of Liberty to the United States as a token of friendship between the two countries. It becomes a symbol of hope for millions of immigrants.

1889 Buffalo Bill stages his Wild West Show at the Paris world's fair, with shooting feats by Annie Oakley, mock battles between Native Americans and the U.S. Cavalry, and displays of cowboy skills.

1883 The Orient Express makes its first run from Paris to Istanbul. By the 1880's, trains travel throughout Europe and the United States on over 100,000 miles of railroad tracks.

1886 Sarah Bernhardt, the most celebrated actress of her day, embarks on the first of many triumphant world tours. She travels with twenty pets and a gold-trimmed coffin that she keeps at the foot of her bed.

1894 Alfred Dreyfus, a Jewish captain in the French army, is wrongly convicted of treason for passing military secrets to Germany. He is a victim of anti-Semitism. The Dreyfus Affair causes intense controversy in France and international outrage.

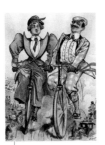

1890's Bicycle riding becomes the new rage in Paris. Clothing fashions change so that women can ride them, and the bicycle becomes a symbol of a new and more liberated way of life.

1902 Claude Debussy's opera, *Pelléas et Mélisande*, is performed for the first time, earning him wide-spread fame. He becomes known as the composer of "musical impressionism."

1908 Henry Ford introduces the Model T, the first automobile made on an assembly line. Cars soon become affordable for people other than the very rich.

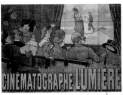

1895 French brothers, Louis and Auguste Lumière, invent a movie camera and shoot the first motion pictures ever made.

1898 Marie Curie discovers radium and radioactivity. She becomes the only person ever to win two Nobel Prizes: first in physics and, years later, in chemistry.

1903 The Wright brothers, Wilbur and Orville, build and fly the first airplane during time off from their bicycle business. Their first flights last less than a minute. Within two years, they fly a plane 25 miles in 29 minutes.

1909 Admiral Robert Peary and African-American explorer Matthew Henson, along with four Inuit, are the first people to reach the North Pole.

1895 1900 1905 1910 1915

1896 Alfred Nobel, the inventor of dynamite, wants to be remembered for something nobler. He bequeaths his fortune to establish the Nobel Prize.

1896 The first Olympic games of modern times are held in Athens, Greece.

1899-1902 Dutch settlers in South Africa fight the British in the Boer War. Africans suffer greatly as Europeans wage war for control of their homeland and its rich natural resources.

1900 Sigmund Freud, the founder of psychology and psychotherapy, publishes his groundbreaking book, *Interpretation of Dreams*.

1905 Albert Einstein publishes his special theory of relativity at the age of 26. Over the next several decades, his work revolutionizes our understanding of the universe.

1914 The U.S. completes work on the Panama Canal. For the first time, ships can travel between the Atlantic and the Pacific without going thousands of miles around South America.

1914 World War I begins. Over the next four years, the conflict will involve 32 nations and over 65 million men. Nearly half will be wounded or die in the fighting.

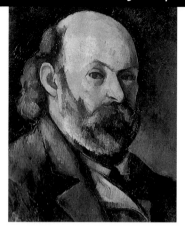

Paul Cézanne

1839 – 1906

At school, Paul Cézanne excelled in Latin, Greek and French literature, but when he went to Paris to study art, he was taken for a country bumpkin. He was shy and had a strong provincial accent. The School of Fine Arts refused to admit him so he studied on his own. When Cézanne first exhibited his art, the critics and public hated it. One critic called him "a jackass painting with his tail." Stung by the insults, he returned home to the South of France where his father, a rich banker, supported him. When he was 47, Cézanne finally married the mother of his 14-year old son. He continued to paint until a few days before he died at 67.

Georges Seurat

1859 – 1891

As a young boy, Georges Seurat knew he wanted to be an artist. His uncle painted as a hobby and took him out on art expeditions. At 15, Seurat began drawing classes then pursued a classical art education at the School of Fine Arts in Paris. During his ten-year art career, Seurat spent most of his time on just seven large paintings, working for a year or more on each one. He became the leader of a group of artists, called neo-Impressionists, who subscribed to his scientific theories of art and painted with dots and dashes of pure color. When he was 31, Seurat died suddenly of diphtheria.

Paul Gauguin

1848 – 1903

Paul Gauguin spent his early childhood with his mother's aristocratic relatives in Peru. There his life was carefree and full of color. When he was six, his family returned to a much drearier life in France. At 17, Gauguin went to sea for six years then settled in Paris to become a successful businessman. He married a young Danish woman and they had five children. For twelve years, Gauguin painted as a hobby but gradually art became his passion. At 35, he quit his job to be an artist then abandoned his family to search for a freer, simpler way of life. He spent ten of the last twelve years of his life painting in the South Pacific, where he died at 54.

Vincent Van Gogh
1841 – 1895

On March 30, 1852, a Dutch minister and his wife had a stillborn son named Vincent. On the same day a year later, they had a second son named Vincent, who grew up feeling like a substitute for his dead brother. He desperately wanted to make a contribution to humanity to make his life worthwhile, but at 27, he felt like a failure. He had been fired from his jobs as an art dealer and a lay minister, and he had fallen in love twice and been rejected both times. Then he decided to dedicate his life to art. In the next ten years, he taught himself to draw and paint and created hundreds of masterpieces.

Henri Rousseau
1844 – 1910

Henri Rousseau was born to a poor tinsmith and his wife in northwestern France. He was not a very good student and showed no particular talent for art when he was young. On days off from his job as a customs agent, Rousseau taught himself to paint. At 41, he quit his job so he could paint full-time. To make ends meet he taught music and art to people in his neighborhood; at times he even resorted to playing his violin on street corners. Rousseau was quite poor yet he always shared what little he had with others. Towards the end of his life, art collectors began to buy his paintings, but he sold them for very little and died a pauper at 66.

Henri de Toulouse-Lautrec
1864 – 1901

Henri de Toulouse-Lautrec was born to a wealthy aristocratic family. He suffered from an inherited condition that made his bones fragile. When he was young he broke both legs. The bones never healed properly and his legs stopped growing, leaving him crippled. He turned his energies to drawing and painting. At 17, he moved to Paris and found friends among artists and entertainers. For almost twenty years he painted at a feverish pace, producing hundreds of paintings, posters and prints. During that time, he also drank heavily. His alcoholism contributed to his early death at 36.

Cézanne made almost two hundred still life paintings, sometimes spending weeks, or even months, on a single one. He explained why he painted fruit: "I decided against flowers, they wither on the instant. Fruits are more loyal....They appear with all their scents, they speak of the fields they have left behind, the rain that nourished them, the dawns they have seen."

Unusual brushstrokes

In most paintings, artists follow the curves of each object with their brushstrokes. In this painting, the brushstrokes go mostly in one direction, like needlepoint stitches. To make the pieces of fruit look round and solid, Cézanne used some colors that pop out and others that recede. His brushstrokes add texture and a sense of unity to the painting.

Leaping wallflowers

Cézanne did not want people to look only at what was in the foreground. He used different techniques to keep your eye moving all around a painting. Here, the flowers on the wallpaper appear to leap out over the bowl of fruit.

Painted love

Cézanne dedicated his life to his art. Over the years he became more and more like a hermit, only leaving his work to eat, sleep, and go to church on Sunday. He even missed his mother's funeral in order to paint. The poet Rainer Maria Rilke described how Cézanne poured all his love into each of his paintings: "He knew how to swallow back his love for every apple and put it to rest in the painted apple forever."

"I should like to amaze Paris with an apple." — Paul Cézanne

Paul

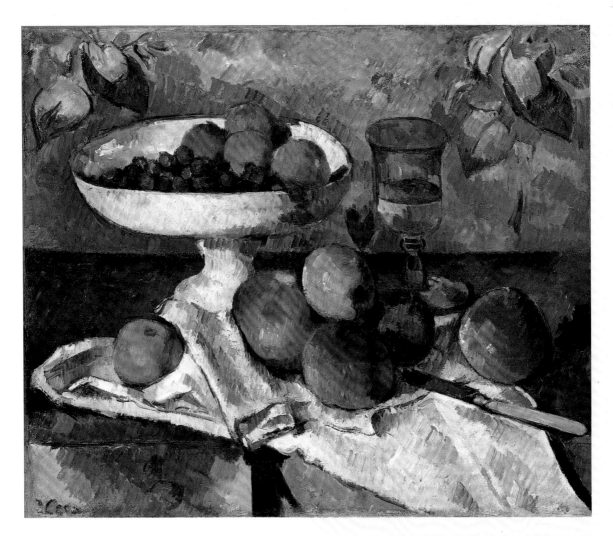

"You're making fun of me"

For years art critics ridiculed Cézanne and his paintings, but some of the greatest Impressionist artists loved his work. One day, Claude Monet noticed that Cézanne had lost confidence in his artistic ability. He decided to boost Cézanne's morale with a lunch in his honor. At the party, Monet began to express the admiration he and his fellow artists felt for Cézanne, but Cézanne refused to believe it. "You're making fun of me!" he cried and stormed out of the party.

STILL LIFE WITH FRUIT DISH, 1880, oil on canvas, 18" x 22" (46 x 55 CM), Private Collection.

Art for inspiration

Paul Gauguin used to own this painting. He wrote to a friend, "Unless I am absolutely down to my last shirt, I will hang on to it for dear life." Gauguin was so inspired by Cézanne's art that he would say to himself as he set off to paint, "Let's go and make a Cézanne."

Cézanne painted with Impressionist artists Monet, Renoir, and Pissarro, and exhibited his work in the early Impressionist exhibitions. But from the beginning he painted differently from the Impressionists. They wanted to "capture the light and throw it onto the canvas," while he wanted to depict nature as more solid and permanent.

Two ways to paint water

Monet and his fellow Impressionists painted water filled with waves and reflections. Cézanne's water appears almost solid. The strong blue color he used makes the bay stand out in a triangular shape.

Regattas at Argenteuil, Claude Monet, c. 1874

A different kind of depth

Ever since the Renaissance, artists created a sense of depth and distance in paintings with a technique called atmospheric perspective. Anything meant to look far away was painted blurry and in dimmer colors. Cézanne did not do this. He wanted all the parts of his picture to be equally important, with nothing fading away into the distance. Here, the bay and the far mountains are as sharp and bright as the nearby houses. Cézanne used other ways to give the painting a sense of depth. He painted the far shore with less detail. We can see individual trees and houses on the near shore but not across the bay. And he overlapped the houses so that some look closer than others. All this makes the painting appear both flat and deep.

"I am using all my ingenuity to find my true path in painting."

— *Paul Cézanne*

Paul

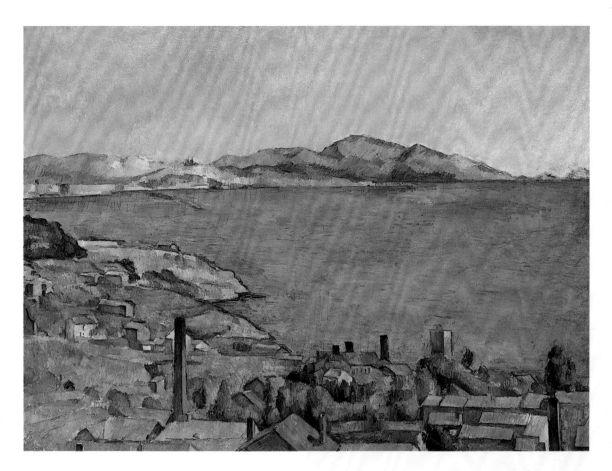

Art found among the rocks

Cézanne and Impressionist artist Auguste Renoir
were close friends. They liked to wander the
countryside together then set up their easels to
paint side by side. Looking back on their painting
days together, Renoir recalled, "With Cézanne it
was always the picture ahead of him that he
cared for, he thought little of what he had already
done. I have some sketches of his that I found
among the rocks of L'Estaque where he worked.
They are beautiful, but he was so intent on others
— better ones that he meant to paint — that he
forgot these or threw them away as soon as he
had finished them."

THE GULF OF MARSEILLE, c.1885, oil on canvas, 29" x 40"
(73 x 100 CM), Metropolitan Museum, New York, U.S.A.

Flat as a playing card

Renaissance artist Leonardo da Vinci advised
artists to paint late in the day when shadows add
depth and mystery to a scene. Cézanne did just
the opposite. He painted when the sun was high
in the sky. He wrote, "It's like a playing card here.
Red roofs and the blue sea. The sun is so fierce
that I feel as though every object was simply a
silhouette, not just in black and white, but in
blue, red, brown, violet. It seems as though this
is the opposite of three-dimensionality."

*C*ézanne wanted to show the life and spirit in everything he painted. Here, he made the pottery and pieces of fruit lean towards each other as if in conversation. Cézanne once confided, "These glasses, these plates, they talk among themselves."

Topsy-turvy table

As he painted the table, Cézanne shifted his point of view. When he painted the left side, he was looking down at the table more than when he painted the right side. That makes the right side look higher. Imagine what the table would look like without the tablecloth — quite odd!

Unstill life

In this more traditional still life painting by Chardin, we can see the side of the bowl but not what is inside it. Cézanne shows us both at once. Chardin's fruit sits quietly on a level table. Cézanne's table is so tilted that

The Silver Goblet
Jean-Baptiste-Siméon Chardin, 1700's

some pieces of fruit look ready to roll off. This gives Cézanne's scene a lively sense of movement and drama.

Paul

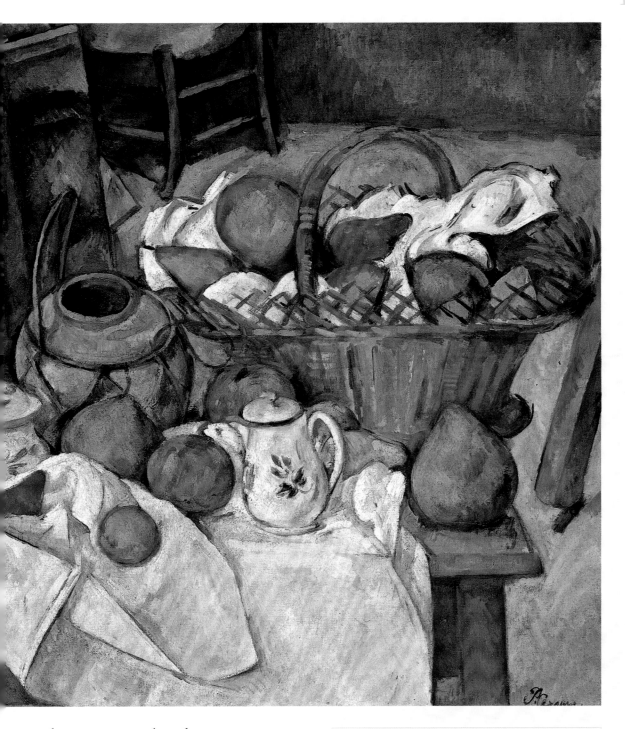

"There are people who say a sugar bowl has no soul, yet it changes everyday." — Paul Cézanne

KITCHEN TABLE, 1888-1890, oil on canvas, 26" x 32" (65 x 80 CM), Musée d'Orsay, Paris, France.

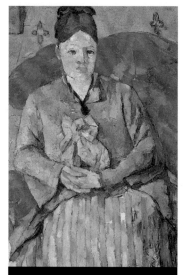

A model wife

Madame Cézanne was a patient woman. She posed for more than forty portraits. But from the paintings it is hard to tell what she looked like or anything about her. Cézanne was not interested in conveying her human aspects. He painted her like a still life, focusing on the interplay of colors and shapes on the canvas.

Madame Cézanne in a Red Armchair, 1877

Cézanne's wife looks so still she almost seems fixed in stone. Cézanne distrusted the Impressionists' desire to paint fleeting moments in time. Instead, he wanted to give scenes a sense of permanence and timelessness.

"Does an apple move?"

When Cézanne started a portrait, he insisted that the person remain frozen in the same position for hours. If his model became restless, he would snap, "Does an apple move?" To make matters worse, Cézanne worked very slowly. One man came to Cézanne's studio over one hundred times to have a single portrait painted; he sometimes had to sit still for three hours at a time. Once he fell asleep and fell off his seat. "Fool!" cried the gruff artist. "You've ruined the pose!"

Van Gogh and Cézanne

Cézanne and Van Gogh met only once, at an art supply shop in Paris. The shopkeeper, Père Tanguy, often gave paint supplies to struggling artists who had no money to pay for them, and he displayed their paintings in his shop to help sell them. On seeing Van Gogh's work, Cézanne is reported to have said, "You paint like a madman!" In fact, the two artists painted very differently. Van Gogh dabbed paint onto his canvas in rapid strokes as if he were conducting a symphony with his paintbrush, while Cézanne carefully chose the color of each brushstroke and placed it precisely on the canvas.

Paul Cézanne

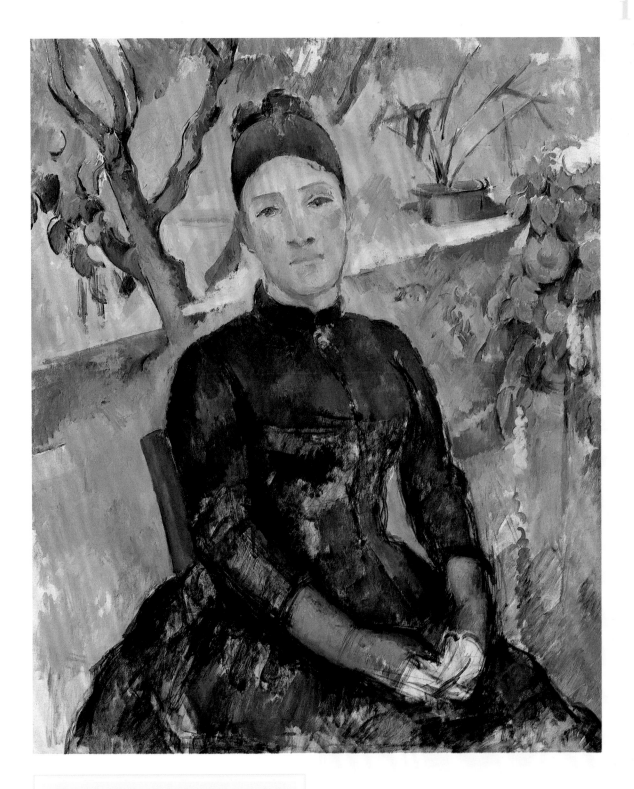

MADAME CÉZANNE IN THE CONSERVATORY, 1891, oil on canvas,
36" x 29" (92 x 73 CM), Metropolitan Museum, New York, U.S.A.

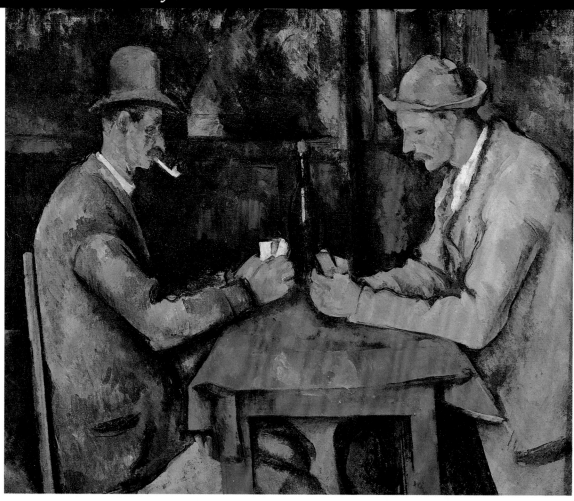

THE CARD PLAYERS, 1893-96, oil on canvas, 19" x 23"
(48 x 57 CM), Musée d'Orsay, Paris, France.

Paul

The kings, queens and jacks on playing cards are made up of colorful, flat shapes. For Cézanne, playing cards were a symbol of what he was trying to achieve in his art. He wanted to create flat-looking paintings, using colors and shapes that were in perfect harmony with one another.

Rough-hewn gentleman

Impressionist artist Mary Cassatt was shocked by Cézanne when they first met, misjudging him for his rough country manners. After he came to her house for dinner, she wrote, "His manners at first rather startled me — he scrapes his soup plate, then lifts it and pours the remaining drops in his spoon; he even takes his chop in his fingers and pulls the meat from the bone. He eats with his knife and accompanies every gesture, every movement of his hand, with that implement, which he grasps firmly when he commences his meal and never puts down until he leaves the table. Yet in spite of the total disregard of the dictionary of manners, he shows a politeness towards us which no other man here would have shown."

Shapely bodies

Cézanne liked to create scenes using simple three-dimensional elements: spheres, cubes, cylinders, and cones. Try drawing your own version of Cézanne's card players, starting with basic shapes. Can you find these same shapes in Cézanne's other paintings?

"Look for the cone, the sphere, and the cylinder in nature."

— *Paul Cézanne's advice to other artists*

*M*ont Saint-Victoire is a massive mountain with a pyramid-like form that towers above the surrounding countryside of Provence. Cézanne was enthralled by the mountain, which he painted many times. As he got older, his paintings of the mountain got more exuberant and spontaneous and became more abstract.

Unifying touches of color

Cézanne put touches of orange (the color of the rocks in the foreground) on the distant mountain, and he put touches of the mountain's blue color on the rocks. This gives the painting a sense of unity by relating the two parts to each other. The contrasting colors also keep our eye leaping from the rocks to the mountain and back.

Father of modern art

In forty years, working slowly but constantly, Cézanne completed over a thousand oil paintings, watercolors and drawings. He created a whole new style of painting that was a major inspiration to later artists. Cézanne showed people that emotionally powerful paintings could be made of shapes and colors that do not look much like things in the real world. He opened the door for later modern artists, who created more abstract paintings. Cézanne became known as "the father of modern art."

Paul Cézanne

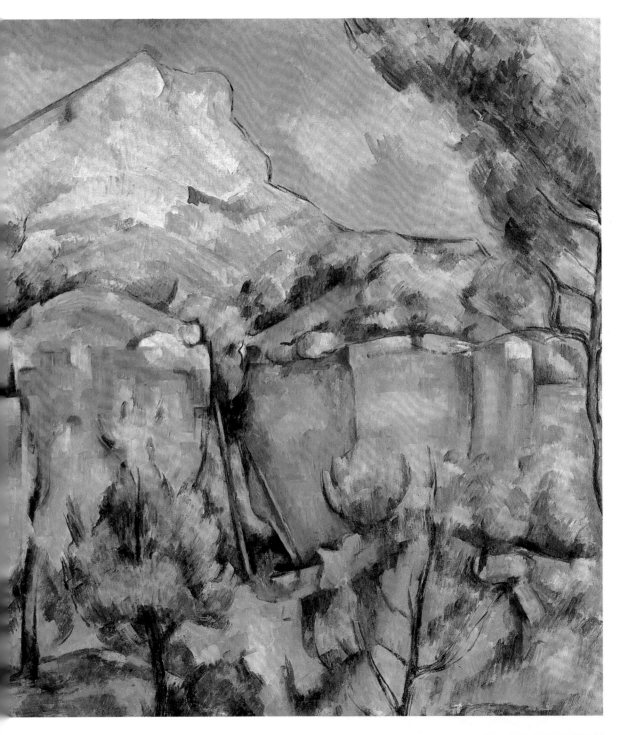

"Cézanne is the parent of us all."

— Pablo Picasso

MONT SAINTE-VICTOIRE SEEN FROM THE BIBÉMUS QUARRY, c.1897, oil on canvas, 26" x 32" (65 x 80 CM), The Baltimore Museum of Art, U.S.A.

When Seurat painted this, he had not yet developed his technique of painting in tiny dots. Here, he has painted water much as the Impressionists did.

Men and boys relax along the banks of the Seine River at Asnières, an industrial suburb of Paris. They are just across the river from the island of La Grande Jatte. The factory smokestacks in the background are reminders of modern industrial life.

Still as statues

The Impressionists painted spontaneous scenes that gave the sense that each moment is brief and gone in an instant. Seurat wanted to do the opposite. Like Cézanne, he gave scenes of everyday life a sense of permanence. His people have a statue-like stillness and appear to be frozen in time.

Radiant auras

Seurat has surrounded the bathers with a faint white band of light so they stand out more clearly from the background. It also makes them appear radiant and alive. This is a *real* light effect. Look at your own hand in front of a white wall in bright light. You may see a similar aura next to your skin.

Georges *Seurat*

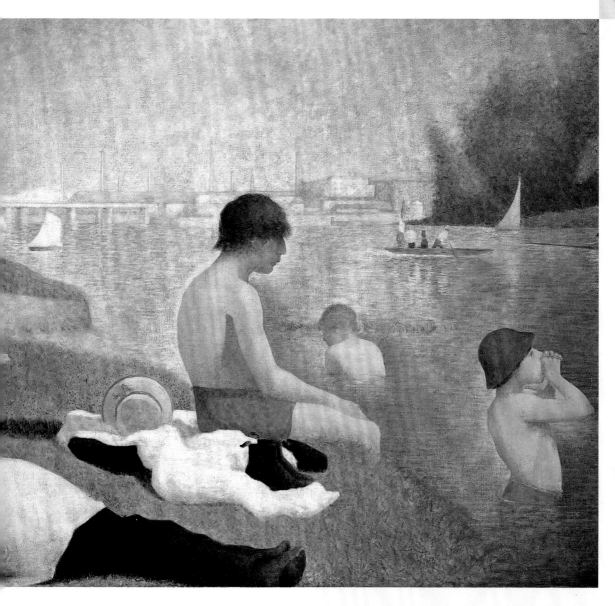

"Let's go out and
get drunk on sunlight."

— *Georges Seurat to his artist friend, Paul Signac*

BATHERS AT ASNIÈRES, 1883-84, oil on canvas, 79" x 119"
(201 x 301 CM), National Gallery, London, England.

*I*n the park, young and old enjoy a summer afternoon. They are on an island in the Seine River, called La Grande Jatte, just outside Paris. For most working people in the 1800's, Sunday was their only day off.

Modern city life

This scene looks old-fashioned to us but in Seurat's day, it was thoroughly modern. Women are dressed in the latest fashions and men row on the river, a new sport in the 1800's. The people in the park are alone or in small groups. No one is calling out or waving to anyone else. This is modern life in a big city, not the small town life that most people led before the Industrial Revolution.

Made-up scene

This scene never actually took place as you see it here. For two years Seurat visited the park, making over sixty preliminary paintings of people, animals, and boats. He painted many sketches on cheap, wooden cigar box covers, then he composed the final scene on a huge canvas in his studio.

Woman with a Monkey, 1884

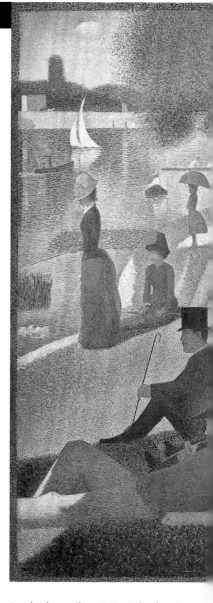

People who see this painting today do not get the full effect that Seurat wanted to create. Some of the colors he used have changed over time. The orange dots he painted as sunny highlights in the grass turned dark, and one of the vibrant greens turned dull.

Georges *Seurat*

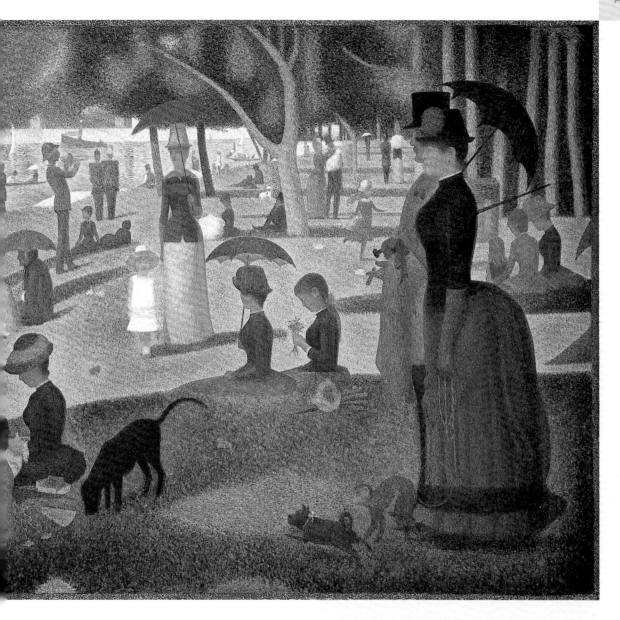

Musical masterpiece

Seurat was only 25 years old when he completed this painting, his greatest masterpiece. It became so famous that it inspired a Broadway musical, Stephen Sondheim's *Sunday in the Park with George*. The play was first performed in 1984, one hundred years after Georges Seurat began work on the painting.

A SUNDAY AFTERNOON ON LA GRANDE JATTE, 1884-86, oil on canvas, 81" x 121" (208 x 308 CM), Art Institute of Chicago, U.S.A.

A fleet of boats sails out to sea from the harbor of a fishing village. Gusts of wind cause patches of ripples in the harbor, making the water look darker in some spots. The boats are larger than they seem; Seurat painted them from a high cliff overlooking the harbor.

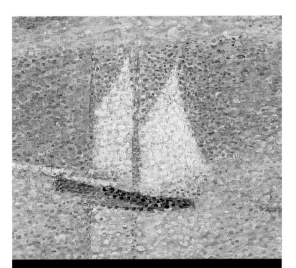

Post-Impressionist water

Notice how different the water in Seurat's painting is compared with Cézanne's *Gulf of Marseille* on page 15. Cézanne wanted to convey a sense of solidity, while Seurat wanted to create sparkling points of light.

Painting with dots

Seurat developed a new style of art, called pointillism, in which he dabbed thousands of small dots and dashes of pure color on the canvas. According to the theories of color and light that he had been studying, tiny dots of different colors, when seen from a distance, would blend together in the eyes of the viewer. In actuality, the dots in Seurat's paintings are too big to blend together this way. Instead they create a mosaic effect. In this painting, thousands of blue, green, and yellow dots give the impression of sunlit water. The effect impressed several artists who adopted Seurat's technique. They thought that tiny dots of different, pure colors created a more luminous and lively image than large brushstrokes of colors that were first mixed on the palette.

"They see poetry in what I have done. No, I apply my method and that is all there is to it."
— *Georges Seurat, on his scientific approach to painting*

Georges *Seurat*

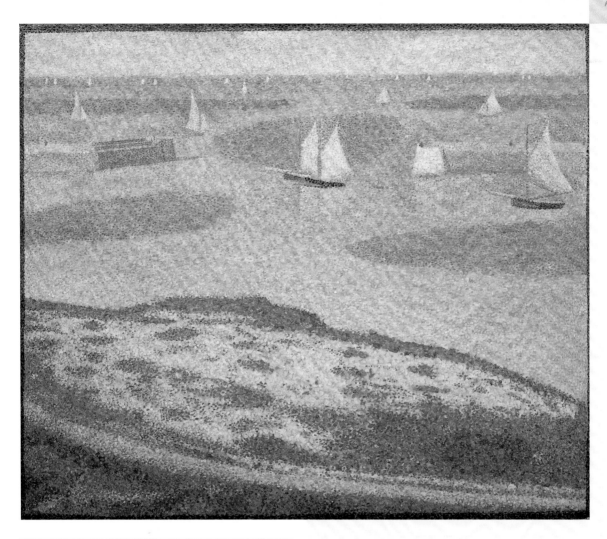

PORT-EN-BESSIN, ENTRANCE TO THE HARBOR, 1888, oil on canvas, 22" x 26" (55 x 65 CM), Museum of Modern Art, New York, U.S.A.

Scientific art

Seurat learned about the physics and chemistry of light and color and then used what he learned to create a new art technique, which some people called "Scientific Impressionism."

Before he began a painting, Seurat knew precisely what concentration of blue, green, yellow, or red dots he wanted on each square inch of the canvas. He stood close to his canvas as he painted, rarely stepping back to see how it looked, and he often painted late into the evening with low light. He could paint this way because he did not rely on his eyes to judge the color effects of his work. He simply followed the color formula he had worked out ahead of time.

Seurat thought his scientific method made his art great, but what really made his paintings come alive were his masterful artist's eye and heart. It is the grace and poetic beauty in his paintings that make them masterpieces.

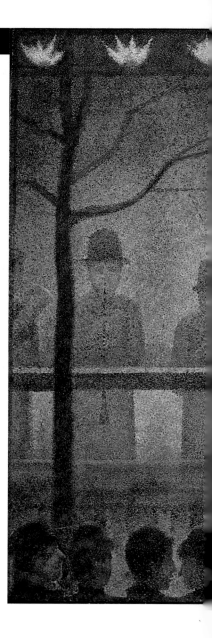

*E*ach spring, a traveling fair came to Paris that included a small circus. Outside the circus tent, musicians played to entice passersby to go in and see the show. Circuses are usually bright and exciting. Seurat painted this sideshow in dark and moody colors that convey the sadder side of life with a traveling circus.

Color psychology

Scientists have discovered that warm colors (in the red-orange-yellow range) actually stimulate the viewer's circulation and cause a slight rise in body temperature. On the other hand, cool colors (those in the purple-blue-green range) cause a slight drop in body temperature. Seurat used warm and cool colors to evoke different moods. When he wanted to create a lively, cheerful effect he used bright tones and warm colors. In this painting, he used dark tones and cool colors to create a melancholy mood.

Georges Seurat

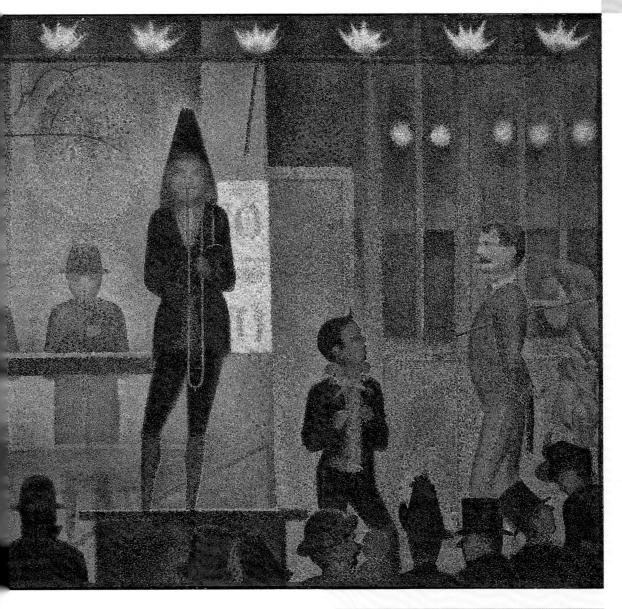

Class hats

The men and women on the right are lined up to buy tickets to the circus. The men on the left can't afford a ticket. They are hanging around, listening to the music. We can tell the social status of each man by the hat he wears. Well-off gentlemen wore top hats while working class men wore caps.

CIRCUS SIDESHOW, 1887-88, oil on canvas, 39" x 59" (100 x 150 CM), Metropolitan Museum, New York, U.S.A.

These dancers are just finishing a high kicking version of the cancan. Seurat's scene is lively but not very happy. The performers wear unconvincing stage smiles, the men's coattails look devilish, and a man with a pig-like snout leers up at the dancers. Seurat has captured both the beautiful and the ugly side of dance hall entertainment.

Dance like an Egyptian

The dance hall performers' perfectly aligned legs are a little like some ancient Egyptian wall paintings. Seurat once said, "I want to make modern people move about as they do on those friezes and place them on canvases organized by harmonies of color."

Servants Presenting Themselves to the Master, c. 1550-1295 B.C.

THE HIGH KICK, 1889-1890, oil on canvas, 67" x 55" (172 x 141 CM), Kröller-Müller Museum, Otterlo, Netherlands.

Language of lines

Seurat believed that different moods and feelings could be conveyed by different kinds of lines. He believed that upward lines suggested gaiety and excitement (like someone waving to get your attention), downward lines conveyed sadness (like a frown), and horizontal lines were calm and restful. This painting is filled with upward lines.

Insults and praise

Many artists who create bold new styles of art face harsh criticism before being accepted. After seeing *The High Kick*, one critic wrote: "Seurat draws and smears with the most supreme ignorance." Another compared his painting to "the mucus of a disemboweled snail." Yet just a year later, Seurat received high praise for *The Circus*, his last masterpiece, which was hailed as "an undulating music of lines."

Georges *Seurat*

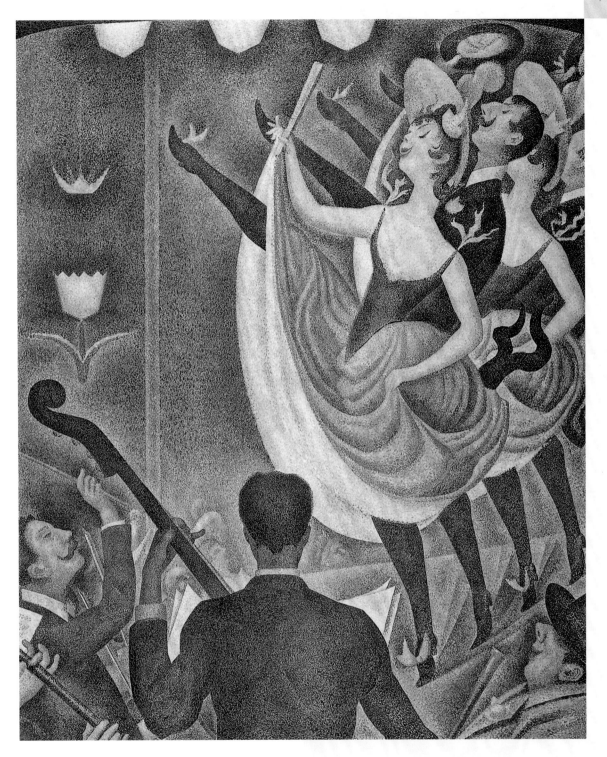

*I*n *The Circus*, Seurat used all his art rules for conveying a sense of fun and excitement. He painted in light shades and warm colors, using lots of red, orange, and yellow, and he used upward lines throughout the painting. Performers' arms and legs, the dancer's dress, the horse's tail, and even the clowns' wigs and fingers all point upwards.

DANCING COLORS
Stare at a ★ for ten seconds, then cover it and look at the white space. You will see an after-image of the star in its complementary color. The blue star will produce an orange afterimage and vice versa. Stare at one of the stars again. After a few seconds, your eye will shift a bit and you will see an after-image around the star's edges. The same effect happens when you look at the dots in a Seurat painting. You see the color he painted and its contrasting after-image nearby. Together, they make the picture flicker and dance before your eyes.

Seurat and Van Gogh

Van Gogh and Seurat were very different. Seurat was calm, quiet, and well balanced, while Van Gogh was nervous and excitable. The year before Van Gogh died, he wrote, "I have often thought that if I had been blessed with the calm temperament of Seurat, I would have been able to survive." Tragically, both artists died young. One day, when Seurat was 31 years old, he suddenly felt very sick. He had been struck with diphtheria, a deadly disease in the 1800's. Three days later, on Easter Sunday of 1891, he died. Both Seurat and Van Gogh had art careers of only ten years. In that short time, each of them changed the world of painting.

Framed in dark dots

Seurat painted a border of dark dots around many of his works to heighten the effect of the lighter colors in the picture.

Georges Seurat

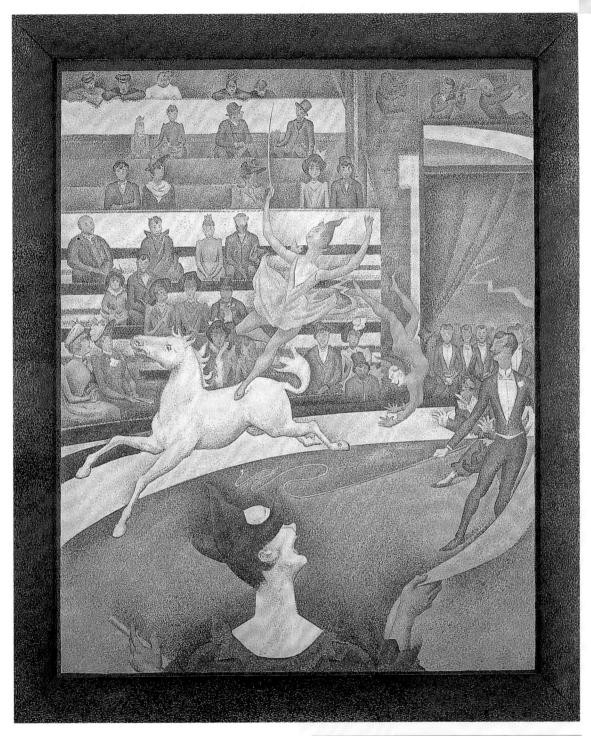

The clown with his back to us looks like he's about to turn the page of a large picture book. Or is it a curtain that he has opened to reveal the circus scene to us?

THE CIRCUS, 1891, oil on canvas, 73" x 60" (186 x 151 CM), Musée d'Orsay, Paris, France.

*T*hree girls dance in a field next to their village. They are dressed in their Sunday best. The women and girls of Brittany wore a traditional costume and wooden shoes to church and on special occasions.

From stockbroker to broke

Before he became an artist, Paul Gauguin was a prosperous stockbroker and art collector. He and his wife and five children lived in an elegant apartment in Paris, where Gauguin painted as a hobby on his days off. After twelve years as a "Sunday painter," Gauguin quit his job to paint full time. He thought he could make a living selling his paintings, but few people wanted his art. His family became poor. They were forced to sell their nice things to buy food. His wife and children finally moved back to Denmark to live with her family. Gauguin spent the rest of his life living hand-to-mouth and hoping to become a successful artist.

Painting tradition

After quitting his job at the bank in Paris, Gauguin moved to Brittany to paint and live more cheaply. While the rest of France was industrializing, time seemed to stand still in Brittany. The people lived simple lives as farmers and fishermen. They were very religious and resisted modern ways. Moving to Brittany was Gauguin's first attempt to get away from modern city life.

Paul Gauguin

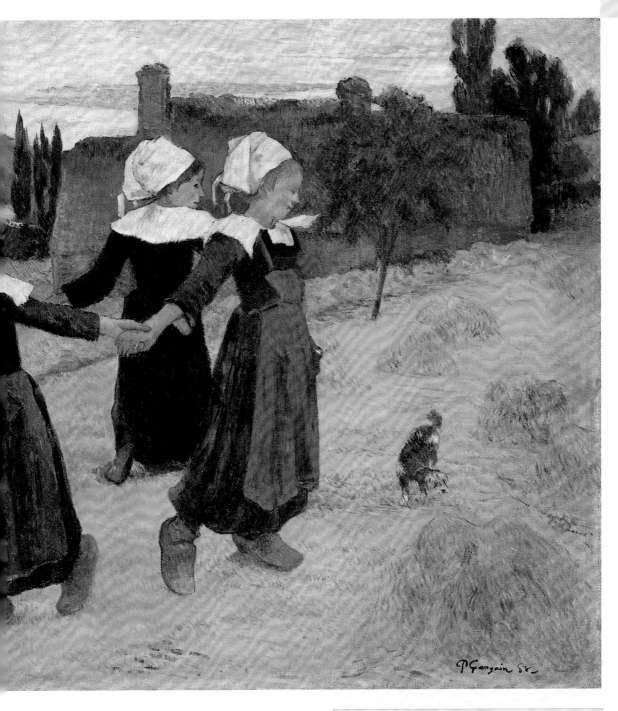

"When my clogs strike this granite ground, I hear the muffled, powerful tone I seek in my painting."

— Paul Gauguin

BRETON GIRLS DANCING, PONT-AVEN, 1888, oil on canvas, 28" x 37" (71 x 93 CM), National Gallery, Washington, D.C., U.S.A.

*W*here are these puppies? On a cloth-covered table or nowhere in particular? It's hard to tell. Gauguin was not interested in locating the puppies in a real-looking space. Instead, he placed them on a background of lightly painted, decorative shapes.

The simpler the better

When he moved to Brittany, Gauguin began to find his own style in art that was less like the Impressionists'. He started painting simpler shapes with less detail, he drew black outlines and filled them in with areas of solid color, and he stopped painting real-looking backgrounds. Gauguin painted these puppies with crude bodies and stumpy legs on purpose. He was quite capable of drawing people and animals realistically, but now he wanted to experiment with simplified, iconic shapes.

STILL LIFE WITH THREE PUPPIES, 1888, oil on wood, 36" x 25" (92 x 63 CM), Museum of Modern Art, New York, U.S.A.

Mythic art

In this 1889 design for a plate, Gauguin depicts Leda and the Swan of Greek myth. He was fascinated with myths and stories from different spiritual traditions.

"This year I have sacrificed everything — execution, color — for style because I wished to force myself into doing something other than what I know how to do." — Paul Gauguin

Paul *Gauguin*

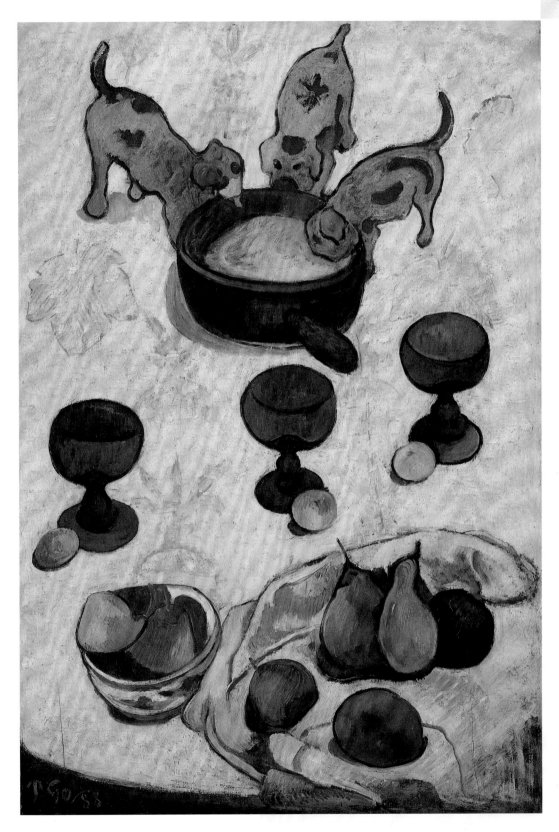

A group of Breton women pray after hearing a sermon about Jacob wrestling with an angel. As they pray, they vividly imagine the scene from the Bible. Gauguin painted the grass red to indicate that the scene before the women is not of this world. The intense color also symbolizes the worshippers' passionate religious beliefs.

Rejected gift

Gauguin's painting looks a little like a stained glass window. It has areas of bright, flat colors outlined in black. Gauguin thought the painting should be hung in a church, but the local priest was shocked by it and refused his gift.

Annunciation, Chartres Cathedral, c.1150

Many sources of inspiration

In searching for a new style, Gauguin found inspiration in many different places. He was inspired by Japanese prints, by the stained glass windows he saw in church, and by the pre-Columbian art he remembered from his childhood in Peru. He was even inspired by the illustrations he saw in children's books.

Painting the invisible

Impressionist artists painted what they saw in the world around them, but Gauguin wanted to paint what he could not see. In this picture, he relates a spiritual experience. Gauguin wrote, "I think I have achieved a great rustic and superstitious simplicity in the figures. For me in this painting, the landscape and the fight exist only in the imagination of the people at prayer. That is why there is a contrast between the people, who are natural, and the struggle going on in a landscape which is not natural and out of proportion." To further help us distinguish between the natural and imaginary parts of the picture, Gauguin divides them with the trunk of a tree.

Paul Gauguin

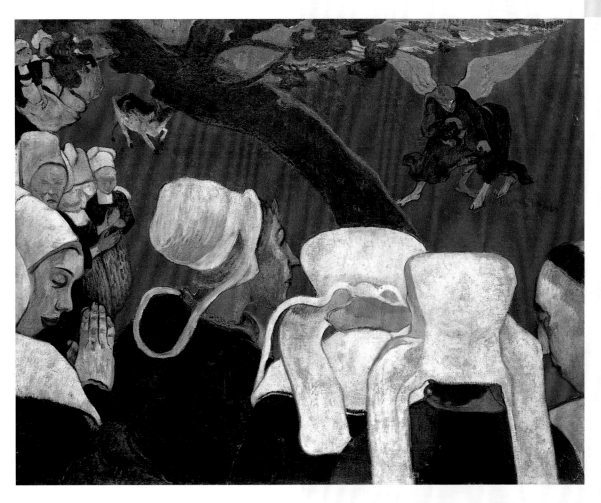

Artist and priest

At the far right, Gauguin painted a picture of himself as the priest who gave the sermon. This was his way of suggesting that artists and priests have something in common. They both help people move beyond their everyday reality to a more spiritual experience of life.

THE VISION AFTER THE SERMON, 1888, oil on canvas, 29" x 36" (73 x 92 CM), National Gallery of Scotland, Edinburgh.

"Color! Language of dreams, so profound, so mysterious."

— *Paul Gauguin*

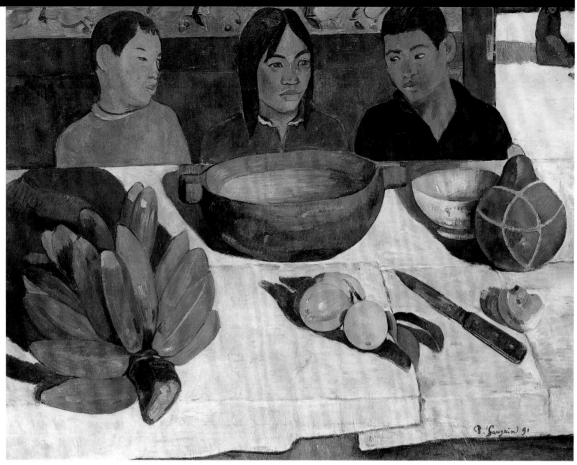

"I am leaving to be at peace, to rid myself of the influence of civilization. I only want to create art that is simple, very simple. To do that I need to renew myself in unspoiled nature." — Paul Gauguin

Paul Gauguin

*T*hree children wait quietly at a table prepared for a meal. The food is laid out on our side of the table, inviting us to join them. Everything in the scene is quiet and still. Gauguin wrote, "The stillness of night in Tahiti is the strangest thing….Here and there a large dry leaf falls but without making the slightest sound. It is more like the rustling of a spirit."

Search for paradise

Gauguin was fed up with modern life in France. He decided to find a more "primitive" place, where he could pick food from the trees whenever he was hungry. First he went to Panama, but he got sick with malaria and had to go home. Then he tried the Caribbean island of Martinique, but it was too civilized for him. He spent two months with Van Gogh in the South of France but wasn't happy there either. Finally, he sailed for Tahiti in the South Pacific. Before he went, Gauguin believed that "Tahitians know only the sweet things in life. For them, life is singing and loving." But when he got there, he found that Tahiti was no longer the primitive paradise he'd expected. Missionaries had brought Western religion and the French had governed it as a colony for fifty years. Tahitians had been pressured to abandon much of their culture and adopt Western ways.

THE MEAL (BANANAS), 1891, oil on paper mounted on canvas, 29" x 36" (73 x 92 CM), Musée d'Orsay, Paris, France.

Real and imaginary Tahiti

After a short while in Papeete, the capital of Tahiti, Gauguin moved to a more remote part of the island. There too, life had been influenced by Europeans, but less so. At last Gauguin had found a place he could love. The people were beautiful, warm, and welcoming. They lived in grass huts surrounded by coconut palms and fruit trees beside the dazzling blue ocean. Using his imagination, Gauguin began to paint scenes that combined his impressions of Tahiti with stories he heard of island life long ago.

Children left behind

Perhaps as he painted this, Gauguin thought of his own children. When he sailed for Tahiti, he left his family behind in Europe. Wherever he lived, he placed photographs of his children on his wall, carefully arranging them in order of their age. He wrote many letters to his family but he never lived with them again.

Beside a lagoon, a woman sits Buddha-like under a tree, listening to her companion play a melody on a Tahitian flute. In the distance, three women honor Hina, Tahitian goddess of the moon. A strange orange dog adds a note of mystery to the painting.

Art from dreams and visions

Gauguin painted many dream-like scenes. He once advised another artist: "Don't copy nature too literally. Art is an abstraction. Derive art from nature as you dream in nature's presence, and think more about the act of creation than the outcome."

Musical colors

Gauguin wanted the colors and images in his paintings to enrapture people the way strange and beautiful music does. Gauguin himself loved to play the mandolin. He once called painting "music's sister" and said, "Musical sensations issue from color….Color, like music, is vibration. It captures what is most elusive in nature: its inner force."

"In painting as in music one should look for suggestions rather than description."

— *Paul Gauguin*

Paul Gauguin

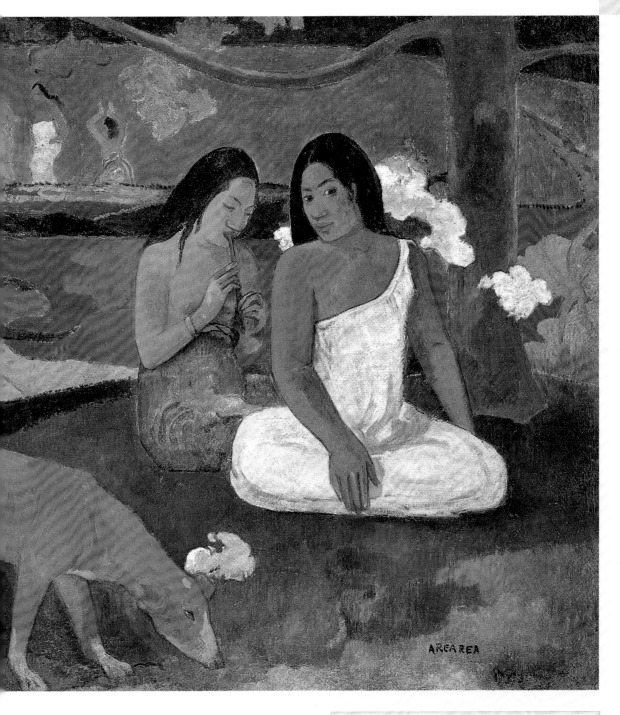

AREAREA (AMUSEMENT), 1892, oil on canvas, 30" x 37"
(75 x 94 CM), Musée d'Orsay, Paris, France.

A white horse drinks from a stream, bathed in green light that filters through the trees. Behind the horse, two people ride bareback through the glen. In his letters home, Gauguin sometimes called Tahiti a "Garden of Eden." Here, he creates a dream-like tropical paradise.

THE WHITE HORSE, 1898, oil on canvas, 56" x 36" (141 x 91 CM), Musée d'Orsay, Paris, France.

Suffering genius

Gauguin was happy with his art but not with his life. For twenty years he struggled to have enough money to eat, have a place to live, and buy art supplies. He was also sick much of the time. For the last several years of his life, he suffered from various diseases and injuries that left him weak, miserable, and in chronic pain. The year before he painted this, Gauguin was in such misery that he tried to commit suicide by eating arsenic, but he ate so much of it that he vomited and survived. Gauguin once wrote to his daughter, "Suffering whets the genius in you. Not too much though, or it'll do you in."

Horse of a different color

Although this picture is called *The White Horse*, it is actually painted in various shades of green. Gauguin painted it for the manager of the local pharmacy. The artist was sick at the time and probably arranged to trade a painting for some pain medications. When the pharmacist first saw the picture, he complained that the horse was an impossible shade of green. Gauguin argued that green was the true color of Tahiti; if the pharmacist just half-closed his eyes, he would see that everything around him was suffused with a beautiful green light. The indignant man replied that he could hardly be expected to half-close his eyes every time he wanted to look at his picture. He refused to accept what has become one of Gauguin's most famous and beloved paintings.

"You will always find nourishment in the primitive arts." — Paul Gauguin

Paul Gauguin

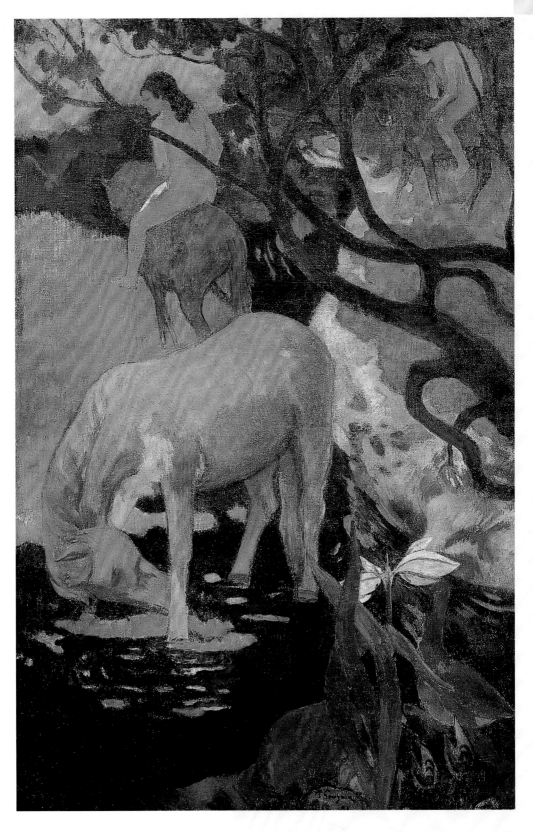

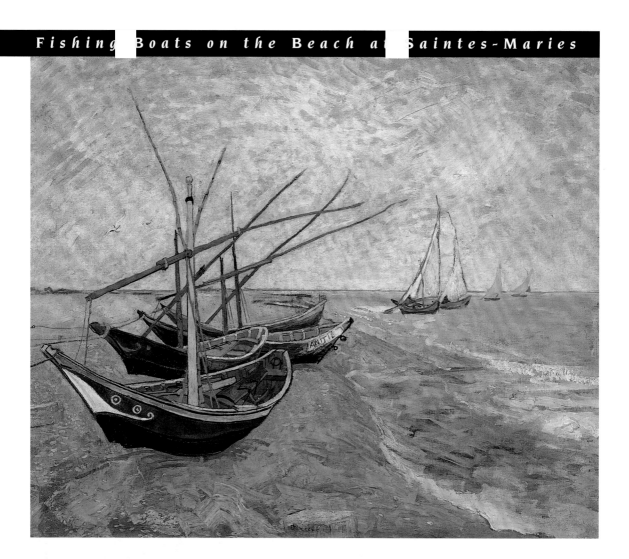

"There is nothing more truly artistic than to love people." — *Vincent Van Gogh*

FISHING BOATS ON THE BEACH, 1888, oil on canvas,
26" x 32" (65 x 81 CM), Van Gogh Museum, Amsterdam, Netherlands.

Van Gogh

Vincent

When Van Gogh painted this scene of fishing boats on the beach and setting sail, he was living alone in the South of France, hoping that other artists would join him. His grand dream was to create an artists' community where friends would live and paint together, helping and inspiring one another.

What friends are for

Four sailboats sit together on shore. Van Gogh named one of the boats *Amitié*, meaning "friendship" in French. This painting symbolizes the importance of friends for Van Gogh. When you have good friends nearby, you can set out on the seas of life knowing you are not alone.

"Strained to the utmost"

Van Gogh put his heart and soul into everything that he did. He once described what it felt like to paint with such passion and intensity: "One's mind is strained to the utmost, like an actor onstage in a difficult part, with a hundred things to think of at once."

Vincent and Theo

Vincent's younger brother, Theo, recognized Vincent's talent before anyone else. Theo did not have much money but he shared what he had with Vincent. For ten years Theo gave Vincent an allowance to live on each month, kept him supplied with canvas and paints, and cared for him when he was sick. Theo, who was an art dealer, also tried to find buyers for Vincent's paintings.

Color discovery

Van Gogh did not always paint with bright and strong colors. When he first started painting in his native Holland, he used a lot of dark colors and more muted tones. Then he went to Paris and saw Impressionist paintings for the first time. Inspired by what he saw, he began to paint with lighter and brighter colors and his brushstrokes became livelier and more distinct.

Quay with Ships, 1885

*I*n their paintings, the Impressionist artists wanted to capture the effects of light as it reflected on things, but Van Gogh did not. He wanted to capture the light he saw radiating from within people and things. He painted these irises without shadows. The flowers are not bathed in an outer source of light, they burst with their own inner energy and brilliance.

A home of their own

Van Gogh was excited that Paul Gauguin was coming to live with him. He made several paintings of sunflowers to decorate the yellow house they would share. Their house is the one on the corner, with the green shutters.

The Yellow House, 1888

IRISES IN A VASE, 1890, oil on canvas, 37" x 29" (94 x 74 CM), Van Gogh Museum, Amsterdam, The Netherlands.

Odd couple

For two months Van Gogh and Gauguin lived and worked together, sharing a little yellow house in the town of Arles in southern France. Vincent believed his dream of an artists' community was beginning to come true. But living and working together was hard for both artists. They were an odd couple. Gauguin liked things to be neat, while Van Gogh was extremely messy. Gauguin liked quiet, serene surroundings, but Van Gogh was full of nervous energy and talked a lot.

They also painted very differently. Gauguin could paint entirely from his imagination. He liked to reflect and dream before he began then carefully plan the shapes he would paint. Instead, Van Gogh liked to have his subject right in front of him as he painted. He too reflected before he began, but once he got started he worked fast. Van Gogh said, "My brushstroke has no system at all. I hit the canvas with irregular touches of the brush, which I leave as they are."

Van Gogh

Vincent

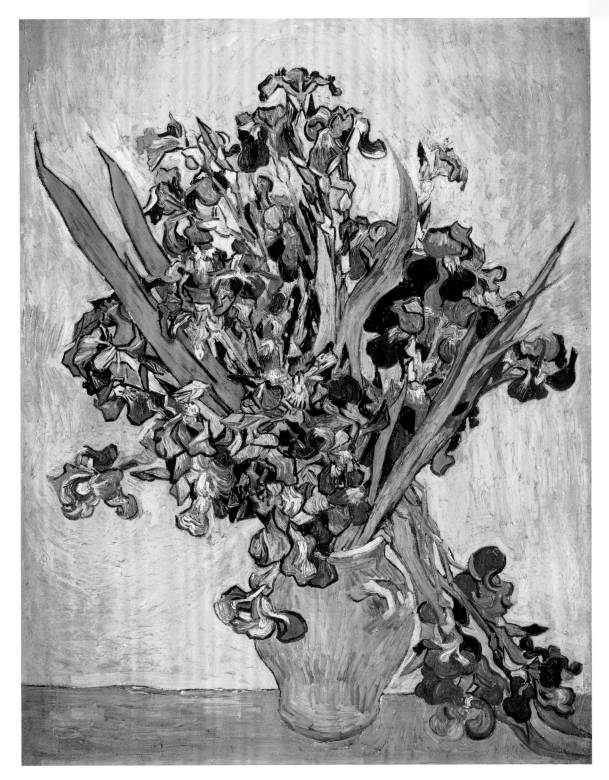

"What color is in a picture, enthusiasm is in life." — Vincent Van Gogh

When Van Gogh painted this picture of his bedroom, he wanted it to "rest the mind, or rather the imagination….The sturdy lines of the furniture should also express undisturbed rest." He chose tones of blue and lavender to convey tranquility, but he also filled the painting with lively combinations of colors and tilted the floor up so much that it seems that the furniture could slide right out of the picture.

Lively color combinations

Vincent used four different pairs of contrasting colors: red and green (on the bed and the chair seats), violet and yellow (on the walls), blue and orange (for the pitcher and the wash stand) and black and white (for the mirror). When contrasting colors appear next to one another, each color makes the other look more vibrant.

Look slowly, paint fast

Van Gogh painted this scene in a single day. While other artists spent weeks or months on a painting, Van Gogh liked to start a painting in the morning and finish it by nightfall. But before he began, he took time to reflect on a scene. He was inspired by Japanese artists who quietly meditated on what they wanted to paint, then painted it rapidly. Van Gogh said, "It is looking at things for a long time that ripens you and gives you a deeper understanding." When he finally sat down to paint, he said his "brushstrokes sometimes come thick and fast like words in a conversation."

"Instead of trying to reproduce exactly what I see before me, I make more arbitrary use of color to express myself more forcefully."

— *Vincent Van Gogh*

Vincent Van Gogh

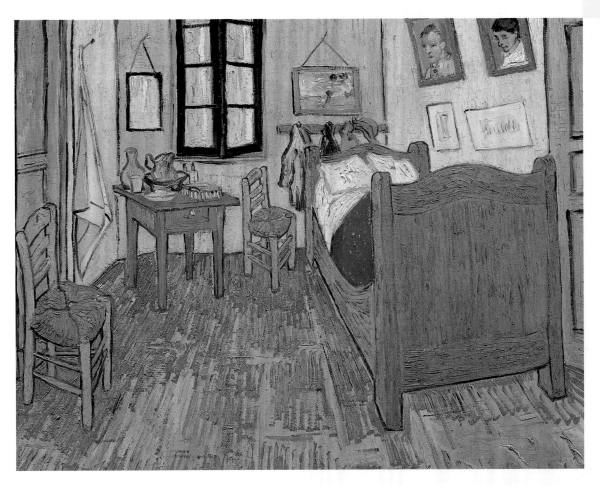

Vincent sent this sketch in a letter to his brother, Theo. He wrote, "At last I can send you a little sketch to give you an idea of the way the work is shaping up….It's just simply my bedroom, only here, color is to do everything…"

THE BEDROOM, 1889, oil on canvas, 22" x 29" (56 x 74 CM), Musée d'Orsay, Paris, France.

What's the difference?

Van Gogh almost always sketched a picture before painting it. There are at least ten little changes he made from the sketch to the final painting that add up to quite a different picture. Can you find them? Why do you think he made the changes?

*S*ince the invention of photography in the early 1800's, portraits painted by artists were no longer needed to show what a person looked like. Van Gogh wanted his portraits to reveal what was on the inside — the psychological or spiritual aspect of a person.

Tragic goodbye

After nine weeks together, Gauguin told Van Gogh he wanted to leave. Van Gogh became very upset. In anger, he almost attacked Gauguin, but in remorse, he turned on himself instead. He cut off his left ear lobe. Frightened by Van Gogh's crazy behavior, Gauguin quickly packed up and left. The two artists never saw each other again, but they remained friends, through letters, for as long as Van Gogh lived.

Colors of passion

Van Gogh painted himself in a green coat against a background of fiery red and orange. He wanted these strong, contrasting colors to convey the intensity of his emotions. Imagine how different the painting would feel if he had chosen a soft blue background. Van Gogh once used red and green together in another painting, saying, "I have tried to express the terrible passions of humanity by means of red and green."

Eyes: windows on the soul

Van Gogh painted this self-portrait just a few weeks after cutting off part of his ear. His eyes seem to reflect the depth of his suffering. He once wrote, "I prefer painting people's eyes to cathedrals for there is something in the eyes that is not in the cathedral."

Mirror image

Look in the mirror and draw a picture of yourself facing to the right. Your drawing will look as if you are facing to the left. Van Gogh used a mirror to paint his self-portrait. It is actually his left ear that is bandaged even though it appears to be his right ear in the painting.

SELF-PORTRAIT WITH BANDAGED EAR, 1889, oil on canvas, 20" x 18" (51 x 45 CM), Private Collection.

Van Gogh

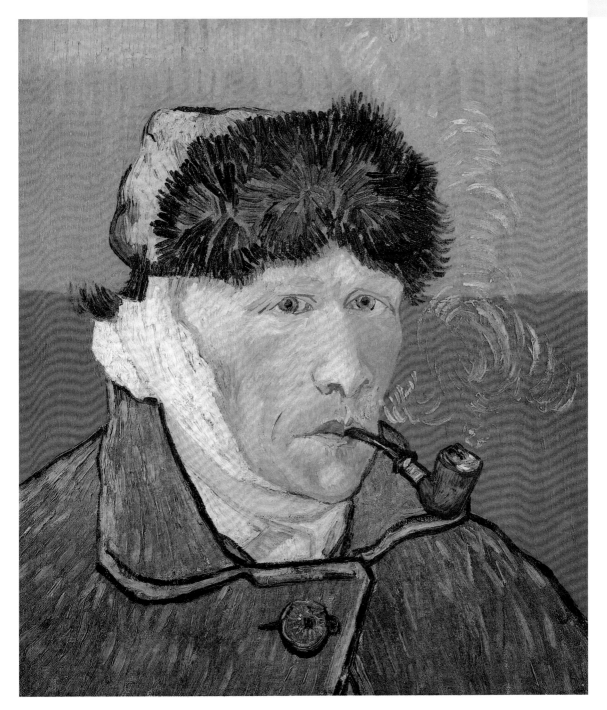

"One seeks after a deeper resemblance than photographs." — Vincent Van Gogh

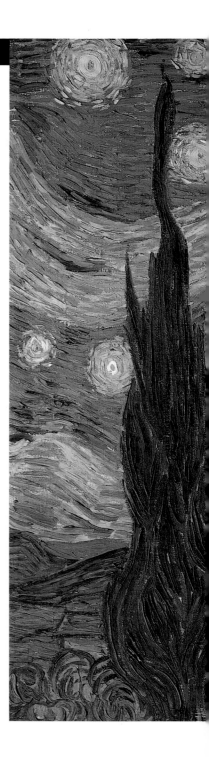

Van Gogh's night sky pulses with life and energy. Two things connect the earth with the heavens: a church steeple (which is man-made) and a cypress tree (a work of nature). While the church barely touches the sky, the tree nearly reaches the highest star.

Imaginary landscape with real stars

Unlike most of his paintings, Van Gogh created this one from his imagination. The hills and tree are like those in the South of France, where this was painted, but the village church is the kind found in Holland where Vincent grew up. Surprisingly, the one part of the picture that Van Gogh painted from real life is the sky. The moon, stars, and planet Venus are in the very positions in which they appeared one evening in the summer of 1888. Low in the sky, Venus shines brighter than the stars.

Not just little white dots

Van Gogh loved to paint the night sky. He wrote to his sister, "It often seems to me that the night is even more richly colored than the day, having hues of the most intense violets, blues, and greens. Certain stars are lemon yellow, others have a pink glow, or a green, blue, and forget-me-not brilliance....Putting little white dots on a blue-black surface is not enough."

Vincent Van Gogh

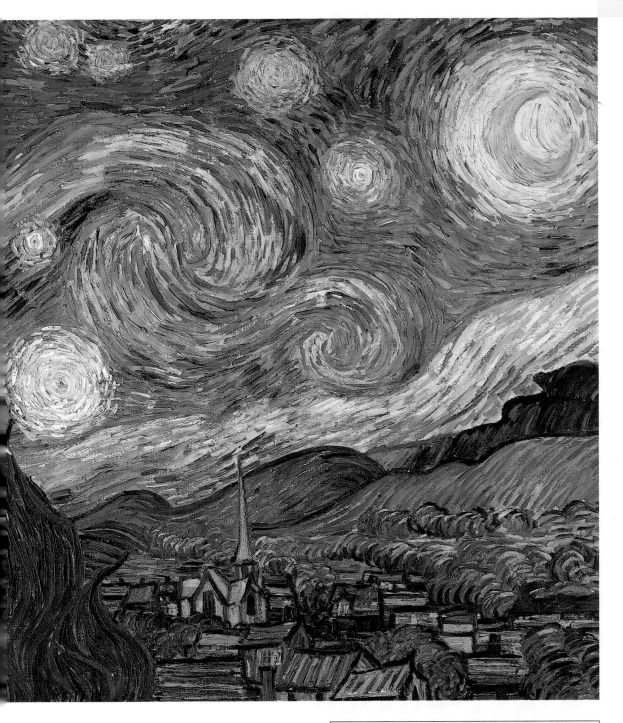

"When I look at the stars
I always start dreaming…"

— Vincent Van Gogh

THE STARRY NIGHT, 1889, oil on canvas, 29" x 36" (74 x 92 CM),
Museum of Modern Art, New York, U.S.A.

*A*fter Gauguin left, Van Gogh struggled to maintain his sanity. He decided to go to a mental hospital, where he remained for a year. Between episodes of madness, his doctors allowed him to paint. This picture captures his love for laborers who work hard for a living.

Thick as paste

Van Gogh put paint on the canvas in thick dabs. Artists call thickly applied paint *impasto*, which means "paste" in Italian. To apply so much paint, Van Gogh often used a knife instead of a brush. Sometimes he even squirted different colors of paint straight from the tubes onto the canvas.

"I am risking my life for my work, and half my reason has gone."

— *Vincent Van Gogh*

Empathy for the poor

When Vincent was a young man he wanted to be a minister like his father, but the church elders were not sure they wanted him. Finally, he was sent as a minister to a poor mining community in Belgium. He was devastated by what he found. The miners spent their lives doing backbreaking work underground in dangerous tunnels. Even young boys were sent into the mines to work long days, breathing coal dust and almost never seeing the sun. For this they earned only pennies a day. Vincent was so pained by the miserable lives of the miners that he gave them all he had: his food, clothes, and money. After the church elders came to visit and saw how he was living, they fired him for not being dignified enough. The intense feelings Vincent had for the coal workers he later poured into his art. He once said, "I want to paint men and women with that something of the eternal which the halo used to symbolize, and which we seek to convey by the very radiance and vibration of our colors."

Vincent Van Gogh

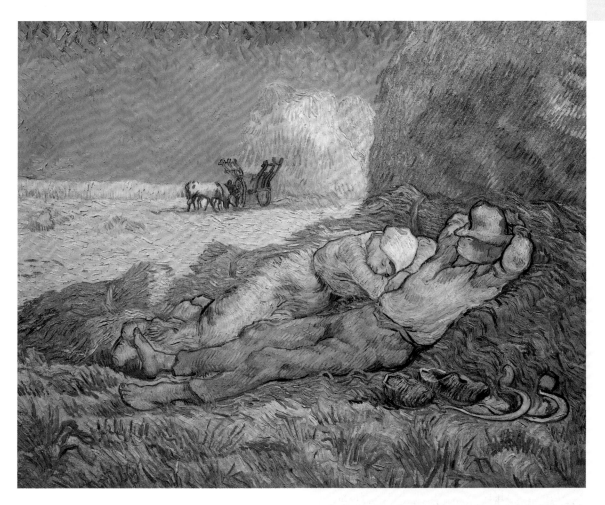

A fiery life and early death

While painting in the South of France in 1888, Van Gogh wrote, "I feel inside me a strength which I must expand, a fire which I cannot put out, but which I must nurture. I do not know to what end it will lead, but I would not be surprised if it were a dark one." In fact, Vincent's fire burned bright but briefly. Over the next three years he painted hundreds of works of art, including many of his greatest masterpieces. Then one day in April 1891, he walked out into a field with his easel and paints and shot himself. He died two days later with his brother, Theo, at his side.

NOONTIME, REST FROM WORK, 1889, oil on canvas, 29" x 36" (73 x 91 CM), Musée d'Orsay, Paris, France.

Suffering artist and mad genius

Vincent Van Gogh painted over eight hundred pictures, but only one was sold in his lifetime. He was not recognized as a great artist until after he died. Over the years, the story of Van Gogh's life became almost as famous as his paintings. He became the archetype of the mad genius who suffers tremendously to create great works of art.

The moon casts its spell over a winter landscape, lighting the way for a couple dressed for a carnival ball. They are in costume as Pierrot and Pierrette, two characters from the old Italian *Commedia dell'Arte* plays. In the plays Pierrot competes with Harlequin to win the love of Pierrette. Harlequin is a clever joker, full of tricks. He usually outwits Pierrot, who is sweet, innocent, and poetic. Rousseau was much like Pierrot. Both of them were musical, romantic, and easily fooled by practical jokers.

Self-taught artist

For over twenty years, Rousseau worked in a toll station on the outskirts of Paris. He inspected carts coming into the city and collected an import tax on goods such as milk, salt, and lamp oil. The job was boring, but he needed it to support his wife and children. Rousseau was over thirty when he started to paint on his days off. He never took drawing or painting lessons; he just looked at the world around him and painted as realistically as he could. In the process, he developed a style all his own that had a childlike quality. People called it "modern primitive."

A CARNIVAL EVENING, 1886, oil on canvas, 46" x 35" (117 x 90 CM), Philadelphia Museum of Art, Philadelphia, U.S.A.

Traced and transformed

Since he never took art lessons, Rousseau found it difficult to make realistic drawings. He often traced or copied figures from pictures he liked. After getting the basic outlines of people and animals onto his canvas, Rousseau painted them into magical and mysterious scenes. Even though he could not draw very well, he was a magnificent painter with a natural artistic genius.

"Anyone whose thoughts aspire to beauty and good should be permitted to create in his own way, in total freedom." — Henri Rousseau

Henri Rousseau

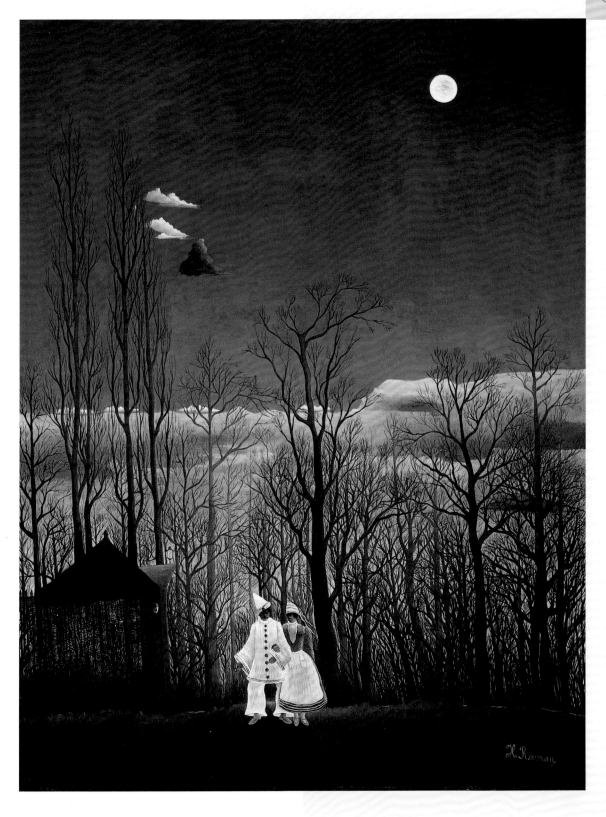

enri Rousseau painted himself as an artistic giant. Look how big he is compared to the two people standing by the river. Rousseau knew he was a great artist and longed for recognition and acclaim. Instead, most people thought his art was awkward and ridiculous.

MYSELF, PORTRAIT-LANDSCAPE, 1890, oil on canvas, 56" x 43" (143 x 110 CM), National Gallery, Prague, Czechoslovakia.

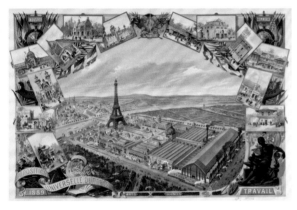

This poster shows the fairgrounds of the 1889 world's fair, with pictures of several exhibit halls. When the Eiffel Tower was first built for the fair, most Parisians considered it an eyesore.

Paris world's fair

Behind the artist is a landscape of Paris during the 1889 world's fair. You can see the Eiffel Tower, built especially for the fair. As a part of the six-month celebration, ships were decked out in flags and a hot air balloon floated over the city.

To love and be loved

For Rousseau, the most important thing in life was to love and be loved. He described his marriage to his first wife as "the happiness of my life." She bore him seven children, five of whom died in infancy. After she died at 36, he remarried. Rousseau honored both of his wives by writing their names on his palette in this picture.

Laughed at

Five years after he took up painting, Rousseau began to exhibit his work in the Salon of Independent Artists, an annual Paris art show. His paintings became one of the great attractions of the show. Even though they were usually hung in a back room, people sought them out like a circus sideshow. Waves of laughter could be heard from those gathered around them. Newspaper columnists advised their readers to go see the paintings if they wanted a good laugh. Throughout his career, Rousseau collected his press clippings in an album, even though almost all of them made fun of him and his art.

Henri Rousseau

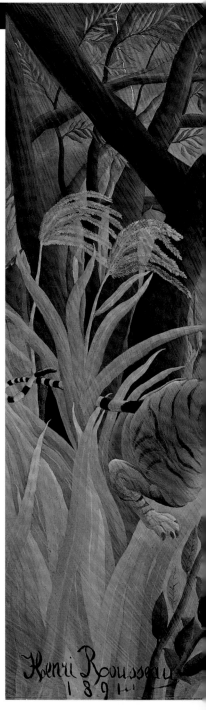

Rousseau is most famous for his jungle paintings. This was his first. He did not paint another one for ten years, but then he painted almost nothing else for the last six years of his life, making more than twenty in all.

Who is surprised?

A tiger stalks through the rainy jungle, ready to take something by surprise…or is it the tiger who has been surprised by the lightning? We cannot be sure. Rousseau shows us the tiger but leaves us to imagine what might be hidden in the tall grasses.

Imaginary jungles

While Gauguin traveled the world to find his primitive settings, Rousseau spent almost his entire adult life in a working class neighborhood of Paris. He never saw a real jungle. Rousseau drew his wild animals from illustrations in books and visits he made to the zoo and the natural history museum. He discovered exotic plants in the hothouses of the Paris Botanical Garden and picked up leaves and branches in his walks around the city. Rousseau used everything he found to create his exotic jungle scenes.

"When I step into the hothouses and see the plants from exotic lands, it seems to me that I am in a dream." — Henri Rousseau

Henri *Rousseau*

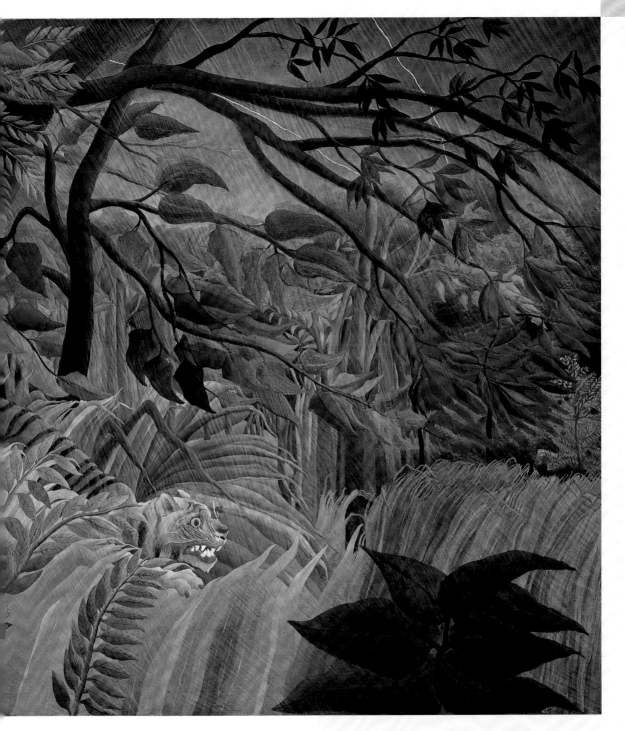

Rousseau's favorite color

In some of his jungle paintings, Rousseau used over twenty different shades of green.

SURPRISE! (TIGER IN A TROPICAL STORM), 1891, oil on canvas, 51" x 64" (130 x 162 CM), National Gallery, London, England.

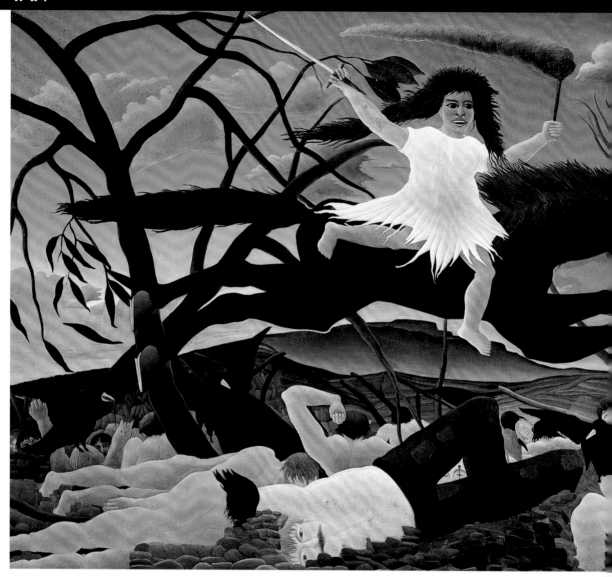

"If a king wants to wage war, let a mother go to him and forbid it."

— Henri Rousseau

Henri *Rousseau*

WAR, 1894, oil on canvas, 45" x 77" (114 x 195 CM),
Musée d'Orsay, Paris, France.

ousseau hated war. He had served in the French army during the Franco-Prussian War. It only lasted a few months, but in that brief time thousands of soldiers were killed and wounded in battle. Soldiers and citizens alike died from disease and starvation.

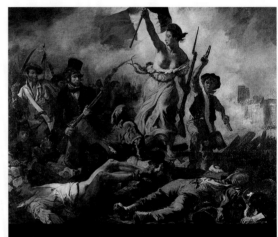

Glory or horror?

Throughout history, paintings of war have shown scenes of glory and triumph, such as this one of the French Revolution of 1830. Rousseau wanted to convey the horror of war. Instead of a beautiful woman, he painted a demonic child with wild eyes and matted hair. Instead of a flag of victory, she carries a smoking torch. The dead do not look like fallen heroes; they are ordinary people being picked at by crows in a barren landscape.

Liberty Guiding the People, Eugène Delacroix, 1830

What do you think will happen next? Will the lion attack the sleeping gypsy or leave her to dream in peace? On the frame of the painting, Rousseau wrote, "The feline, though ferocious, hesitates to pounce upon its prey, who, overcome by fatigue, lies in a deep sleep."

Painting scared

As he worked, Rousseau became a part of the imaginary world he was creating. When he painted frightening scenes of wild animals, he used to sing in a loud voice to keep up his courage. His friend, the poet Apollinaire, recalled that Rousseau sometimes got so scared that he began to tremble and had to rush to the window for air.

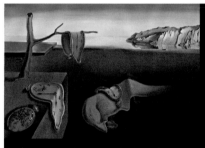

The Persistence of Memory, Salvador Dali, 1931

Surreal scenes

For years Rousseau's art was mocked and called "simple minded." Now it is admired for its simplicity and power. His paintings inspired later artists to create surreal and dreamlike images. This one by Salvador Dali, painted over thirty years later, has a dreamlike quality much like Rousseau's.

Henri Rousseau

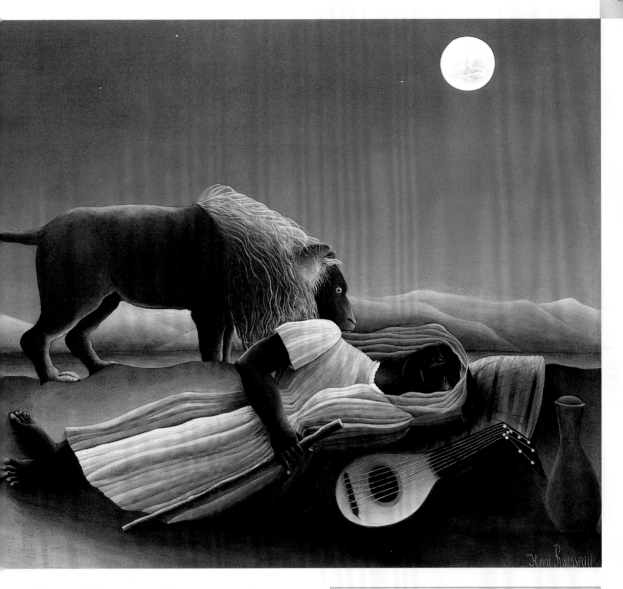

Moved by a spirit

Rousseau believed in ghosts and spirits. He once asked some visitors who were watching him paint, "Did you notice how my hand was moving?"

—"Of course," they said, "you were painting."

—"No, no," he answered, "not I. It was my dead wife who guided my hand. Didn't you see her or hear her? 'Keep at it, Henri,' she whispered. 'It's going to come out right in the end.'"

THE SLEEPING GYPSY, 1897, oil on canvas, 51" x 79" (130 x 201 CM), Museum of Modern Art, New York, U.S.A.

Timeless art

Rousseau called paintings that had a classic, timeless quality "Egyptian-style." He once told Picasso, "We are the two great painters of the age, you in the Egyptian style, I in the modern style."

A mysterious woman charms snakes from the jungle. They seem to dance and sway to the music of her flute. Although there is a moon in the sky, the light is almost as bright as day, while the jungle is dark. This gives the painting an eerie feeling.

Charming animals

Rousseau may have been inspired by stories of snake charmers in India who seem to control poisonous cobras with their flute music. In fact, snakes have very poor hearing. Instead of swaying to music, they sway to the movement of the snake charmer's flute, ready to strike if the charmer gets too close. Rousseau may also have been inspired by the Greek myth of Orpheus. When Orpheus played his music, birds stopped to listen, wild beasts lay down peacefully next to their prey, and even the trees and rocks danced.

Music and tears

Rousseau not only taught himself to paint, he also played the violin, flute, and mandolin, wrote poetry, and composed music. After his first wife, Clemence, died, Rousseau sometimes stood before her portrait and played a violin piece he had composed for her. He would hop from foot to foot as he played, with tears in his eyes.

Picasso's party

While the critics and public laughed at his paintings, a number of artists and writers began to recognize Rousseau's genius. One day, Pablo Picasso decided to hold a banquet for Rousseau, partly to honor him and partly in jest. Picasso decorated his studio with streamers and made a throne out of a packing crate that he surrounded with flags and lanterns. A banner proclaimed "Homage to Rousseau." The party was in full swing when the guest of honor appeared. The little white-haired old man, carrying his cane and violin, brought an emotional hush to the room. For Rousseau, being honored as a great artist was a dream come true. He smiled with tears in his eyes as he took his place on the throne.

Even as they honored Rousseau, the celebrators could not help mocking him a little. When a lantern above his head caught fire, they convinced him it was a sign of divine favor. Eventually, Rousseau dozed off on his throne and snored gently as the party swirled around him.

Henri Rousseau

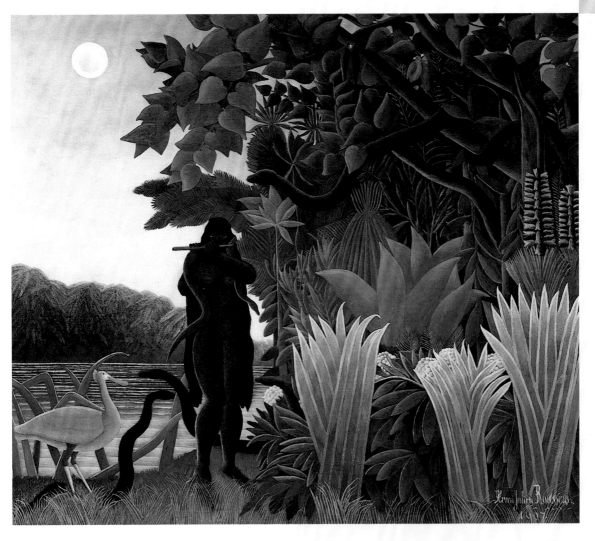

THE SNAKE CHARMER, 1907, oil on canvas, 67" x 74"
(169 x 189 CM), Musée d'Orsay, Paris, France.

How many snakes?

How many snakes can you find in this painting?
Look closely. Some of the snakes look like
branches and plants.

On stream and foliage glisten
The silvery beams of the moon.
And savage serpents listen
To the gay, entrancing tune.

— Henri Rousseau, *in a poem*
describing his painting, The Dream

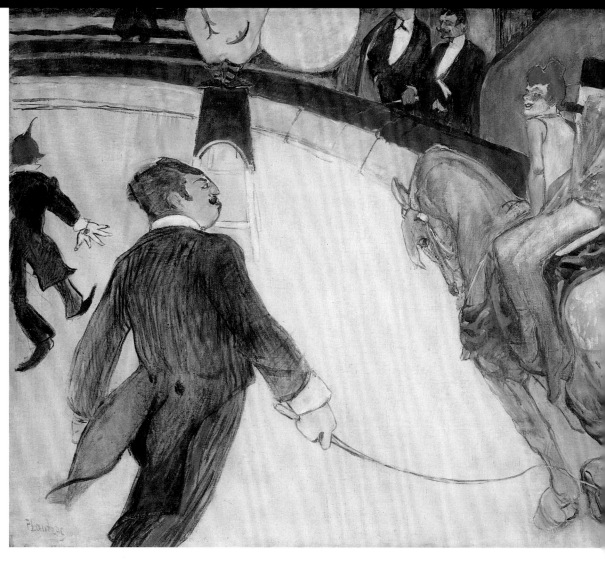

TRICK RIDER AT THE FERNANDO CIRCUS, 1887-88, oil on canvas, 39" x 63" (100 x 161 CM), Art Institute of Chicago, U.S.A.

"I draw and paint as much as I can, so much that my hand gets tired of it." — *Henri de Toulouse-Lautrec*

Henri de Toulouse

*T*he acrobat on horseback is preparing for her next trick. She will leap through a paper hoop held by the clown on a pedestal and land on the cantering horse. The ringmaster keeps the horse moving at a fast pace by flicking a whip on the ground just behind him.

Circus snapshot

The two clowns are cut nearly in half and several audience members have no heads. Lautrec painted this picture as if he were taking a snapshot. In photographs, people and things are often cut off at the edges and anything that moves is likely to come out a bit blurry. Photography was invented in 1839 and immediately had an influence on artists. They began to create photographic effects in their paintings.

Freed by art

For over fifteen years Lautrec lived as an artist in Paris, painting scenes of the circus and Paris nightlife. During those years he drank heavily and became an alcoholic. In 1899, he collapsed drunk in the street and woke to find himself locked up in a clinic. His mother had committed

At the Circus: Chocolat, 1899

him to keep him from drinking himself to death. He pleaded with his father: "Papa, I am confined, and all confined things die." But his father ignored him. He then hoped to gain his release by proving he could still draw. For two months he made circus sketches from memory, including this one. Later he told a friend, "I bought myself out with my drawings."

The woman dancing in the crowd at the Moulin Rouge was known as La Goulue. She was a working class girl who had become one of the most celebrated dance hall performers of her time. La Goulue rose to stardom by inventing her own exciting version of the cancan. She ended her dance by doing the splits while letting out a piercing shriek. Here, she is rehearsing a dance with Valentin "the boneless" who got his nickname for his extreme flexibility.

Beneath the surface

Lautrec liked to reveal what was beneath the surface of his paintings. He applied paint in such thin layers that you can see through them to his initial sketch lines. Here, you can see the dancer's sketched leg beneath her dress.

Dramatic contrast

Lautrec knew that contrast of any kind makes a picture more intense and interesting. Here, he places a woman dressed in a bright pink coat in a dimly lit room crowded with people in dark suits. He also contrasts the stiff and indifferent expressions of the men in the crowd with the vitality of La Goulue's dance.

Henri de Toulouse

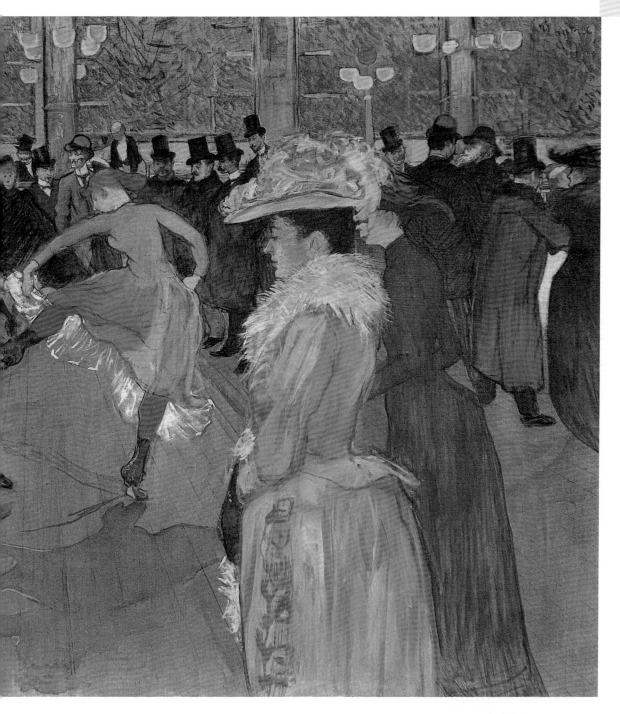

Lautrec diluted his oil paints with lots of turpentine until they were almost as thin as watercolors. His use of very thin paint was quite different from Van Gogh's style of painting with thick dabs straight from the tube.

AT THE MOULIN ROUGE: THE DANCE, 1890, oil on canvas, 46" x 59" (116 x 150 CM), Philadelphia Museum of Art, U.S.A.

H undreds of copies of this poster were printed and put up all over Paris to advertise Aristide Bruant's show at the Ambassadeurs nightclub. Bruant was a folksinger who told jokes and made fun of people in the audience. The poster was an instant hit with the public.

Van Gogh and Lautrec

Van Gogh and Lautrec met as art students in Paris. One day, as they sat together in a café, Lautrec made this pastel portrait of Van Gogh on a piece of cardboard. Lautrec captured Van Gogh's restless intensity in his expression and body language. Lautrec loved Van Gogh's paintings. When an art critic insulted Van Gogh, Lautrec challenged the man to a duel.

Portrait of Vincent Van Gogh, 1887

A taste for art

In his posters and paintings, Lautrec had a special talent for revealing the personality and character of his subjects. A friend of the artist, who posed for his portrait, described Lautrec's way of working: "He placed himself in front of his easel with the small felt hat he always wore in his studio. Then he turned his pince-nez on me, screwed up his eyes, took up his brush, and made a few strokes with very thinned paint. While he was painting, he did not utter a word, but seemed to be devouring something very tasty behind his moist lips."

Two signatures

Lautrec signed this poster twice — with his name at the bottom and with a big red T in the poster itself. Can you find it?

AMBASSADEURS: ARISTIDE BRUANT, 1892, color lithograph, 55" x 38" (141 x 98 CM), Bibliothèque Nationale, Paris, France.

Henri de Toulouse

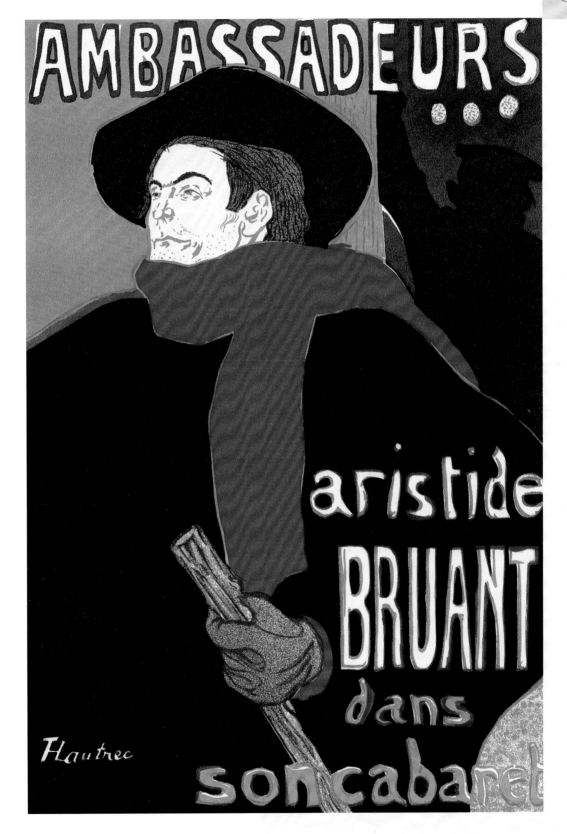

The Moulin Rouge opened in 1889 and immediately became the most popular nightclub in Paris. It was an entertainment emporium with different shows and amusements happening at the same time. There were singers, cancan dancers, belly dancers, trained monkeys, a shooting gallery and places for patrons to dance. The courtyard was dominated by a gigantic papier-mâché elephant with an orchestra playing inside it.

Always drawing

Wherever he went, Lautrec took his sketchpad. He would sit for hours at the Moulin Rouge, drinking with his friends and drawing singers, dancers, and the crowd. Later he painted in his studio, using his drawings as a guide. This painting is filled with Lautrec's friends: writers and performers at the Moulin Rouge. The green-faced woman is probably May Milton, a famous nightclub singer. Lautrec even included himself in the background. The small painter is walking across the room beside his much taller cousin, Gabriel. Behind him the dancer, La Goulue, is fixing her hair in a mirror.

Ugly beauty

Lautrec never flattered his subjects in his paintings of them. He once said, "Always and on every side, ugliness has its notes of beauty."

Dramatic light

For centuries, artists have been fascinated by the effects of light shining up into faces. Until the 1800's, the only such light was from fire. Then gaslight was invented. It was brighter than candlelight and had a greenish glow. Its garish light made masks of people's faces and captured the mood of Paris nightlife.

Saint Sebastian Attended by Saint Irene, Georges de La Tour, c. 1630

Henri de Toulouse

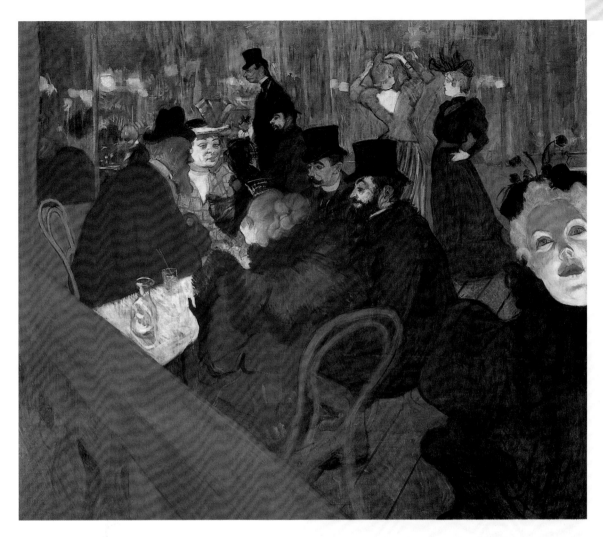

Cut up art

After Lautrec died, the executors of his estate found this painting so strange that they cut off a strip on the right side, thinking it would never sell as Lautrec painted it. The piece with the green-faced lady was later reattached.

AT THE MOULIN ROUGE, 1892-95, oil on canvas, 48" x 55" (123 x 141 CM), Art Institute of Chicago, U.S.A.

"I want to paint until I'm forty, but from forty on I want to be empty."

— Henri de Toulouse-Lautrec, who died at 36

This poster advertised a nightclub called the *Divan Japonais* (the Japanese couch). The singer on stage is the famous Yvette Gilbert who wore long black gloves when she performed. The woman in the audience is also a celebrity. She is Jane Avril, a famous cancan dancer.

Posters became so popular that an international exhibition of them was held in Paris in 1895. A lithograph of Lautrec's, called *The Passenger from Cabin 54*, was used to advertise the event.

From advertising to art

A newly invented printing technique, called color lithography, made it possible to quickly print hundreds of copies of brightly colored posters. For the first time, posters were used as advertising on city walls. Because they were meant as advertising, they had to be eye-catching. Lautrec's posters had simple lines and bold, flat colors. They became hugely popular as fine art. At last, pictorial art was on the streets, not just in museums and art galleries.

Nocturnal art collectors

Lautrec's advertising posters became so popular that people went around Paris on the night a new poster was hung and peeled them off the walls while they were still wet. They took them home to hang on their own walls as art.

DIVAN JAPONAIS, 1893, color lithograph, 31" x 23" (79 x 60 CM), Toulouse-Lautrec Museum, Albi, France.

Henri de Toulouse

This is a horse race at the Longchamps Racetrack outside Paris. All his life, Lautrec loved to paint powerful horses. He drew and painted them from the time he was little, wishing he too had strong legs. But if he'd had them, he might never have become a great artist. He once said that if he'd been physically able, he would have become a surgeon or a sportsman. Instead, his physical weakness led him to create powerful art.

Laughter to hide the pain

Lautrec looked like no one else. Not quite five feet tall, he had the short, thin legs of a sickly child, the upper body of a grown man, and a large head he had trouble holding up. People stared at him, finding him ugly and pitiful. Yet he was a man of enormous talent, intelligence, and wit who was kind and loyal to his friends. Because of his physical deformity, Lautrec felt bitter and angry much of the time, but he hid his unhappiness with laughter, often making jokes about himself before others did.

THE JOCKEY, 1899, color lithograph, 20" x 14" (52 x 36 CM), National Gallery of Art, Washington, D.C., U.S.A.

Artists' gifts

Each of these Post-Impressionist artists created a unique style of art. Cézanne revealed the underlying forms and patterns in nature. Seurat created shimmering mosaics of colored dots, depicting a world frozen in time. Gauguin painted the lost paradise he searched for all over the world. Van Gogh filled his paintings with ecstatic motion, showing us the invisible energies animating everything in nature. Rousseau saw the world through the eyes of a child and painted his enchanted, imaginary world for us. And Lautrec captured life with a new simplicity and power. Each of these artists was inspired by the Impressionists, and they, in turn, inspired generations of artists to paint in bold, new ways.

"Art is the raft that will take us safely to shore." — *Vincent Van Gogh*

Henri de Toulouse

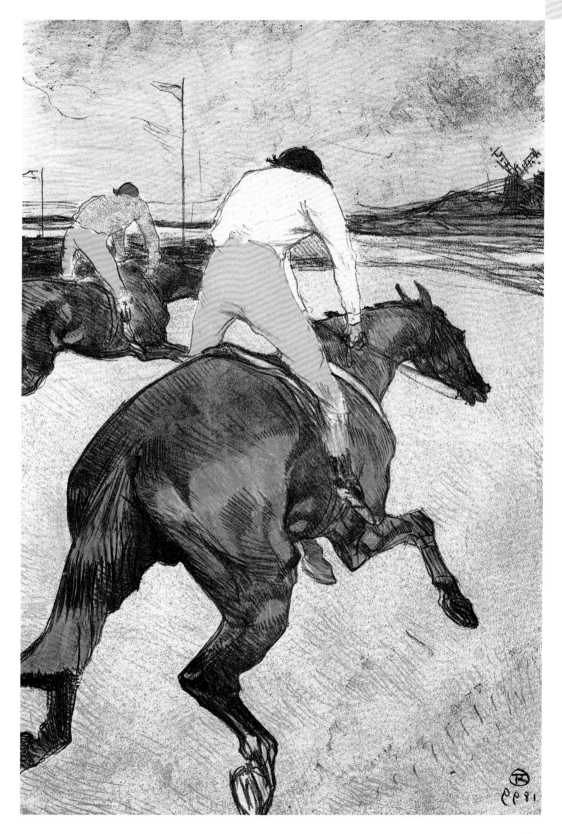

Alley, Ronald. *Portrait of a Primitive: The Art of Henri Rousseau.* New York: E.P. Dutton, 1978.

Arnason, H. Harvard, et al. *History of Modern Art: Painting, Sculpture, Architecture & Photography.* New York: Harry N. Abrams, 1997.

Ball, Philip. *Bright Earth: Art and the Invention of Color.* New York: Farrar, Straus and Giroux, 2001.

Boyer, Patricia Eckert. *Artists and the Avant-Garde Theatre in Paris, 1887-1900.* Washington: National Gallery of Art, 1998.

Boyle-Turner, Caroline. *The Prints of the Pont-Aven School: Gauguin and His Circle in Brittany.* Washington: Smithsonian Institution Traveling Exhibition Service, 1986.

Cachin, Francoise, et al. *Cézanne.* New York: Harry N. Abrams, 1996.

Düchting, Hajo. *Seurat.* Cologne: Taschen, 2000.

Elgar, Frank. *Cézanne.* New York: Praeger, 1975.

Felbinger, Udo. *Henri de Toulouse-Lautrec: Life and Work.* Cologne: Könemann, 1999.

Frey, Julia. *Toulouse-Lautrec: A Life.* New York: Viking, 1994.

Govignon, Brigitte (ed.) *The Beginner's Guide to Art.* New York: Harry N. Abrams, 1995.

Gruitrooy, Gerhard. *Henri de Toulouse-Lautrec.* New York: Smithmark, 1996.

Hartt, Frederick. *Art: A History of Painting, Sculpture, Architecture,* Vol. 2. New York: Harry N. Abrams, 1976.

Herbert, Robert. *Seurat: Drawings and Paintings.* New Haven: Yale University Press, 2001.

Homburg, Cornelia. *Vincent Van Gogh and the Painters of the Petit Boulevard.* Saint Louis: Saint Louis Art Museum, 2001.

Homer, William. *Seurat and the Science of Painting.* New York: Hacker Books, 1984.

Honour, Hugh & Fleming, John. *The Visual Arts: A History.* Englewood Cliffs, New Jersey, 1999.

Janson, H.W. & Janson, Anthony F. *History of Art.* New York: Harry N. Abrams, 1997.

Keay, Carolyn. *Henri Rousseau: Le Douanier.* New York: Rizzoli, 1976.

Kendall, Richard. *Van Gogh's Van Goghs: Masterpieces from the Van Gogh Museum Amsterdam.* Washington: National Gallery of Art, 1998.

Moffett, Charles S. *Impressionist and Post-Impressionist Paintings in The Metropolitan Museum of Art.* New York: The Metropolitan Museum of Art/ Harry N. Abrams, 1991.

Murphy, Richard. *The World of Cézanne.* New York: Time-Life Books, 1968.

Nemeczek, Alfred. *Van Gogh in Arles.* Munich: Prestel, 1999.

Rewald, John. *Seurat: A Biography.* New York: Harry N. Abrams, 1990.

Rilke, Rainer Maria. *Letters on Cézanne.* New York: Fromm International, 1985.

Rosenblum, Robert. *Paintings in the Musée d'Orsay.* New York: Stewart, Tabori & Chang, 1989.

Rosenblum, Robert & Janson, H.W. *19th-Century Art.* New York: Harry N. Abrams, 1994.

Schmalenbach, Werner. *Henri Rousseau: Dreams of the Jungle.* New York: Prestel, 1998.

Shattuck, Roger. *The Banquet Years: The Origins of the Avant Garde in France, 1885 to World War I.* New York: Random House, 1979.

Shattuck, Roger, et al. *Henri Rousseau.* New York: The Museum of Modern Art, 1984.

Sporre, Dennis. *The Creative Impulse: An Introduction to the Arts.* Upper Saddle River: Prentice Hall, 1996.

Sweetman, David. *Paul Gauguin: A Life.* New York: Simon & Schuster, 1995.

Tilston, Richard. *Seurat.* New York: Smithmark, 1991.

Wallace, Robert. *The World of Van Gogh.* New York: Time-Life Books, 1969.

Beaujean, Dieter. *Vincent van Gogh: Life and Work.*
Cologne: Könemann, 2000.

Beckett, Wendy. *My Favorite Things: 75 Works of Art
from Around the World.* New York: Harry N. Abrams,
1999.

Beckett, Wendy. *Sister Wendy's Story of Painting.*
London: Dorling Kindersley, 1994.

Bernard, Bruce. *Van Gogh.* London:
Dorling Kindersley, 1992.

Bonafoux, Pascal. *Van Gogh: The Passionate Eye.*
New York: Harry N. Abrams, 1992.

Cachin, Françoise. *Gauguin: The Quest for Paradise.*
New York: Harry N. Abrams, 1989.

Cole, Alison. *Color.* London: Dorling Kindersley, 1993

Crepaldi, Gabriele. *ArtBook Gauguin.* London:
Dorling Kindersley, 1999.

Frèches, Claire & Fréches, José. *Toulouse-Lautrec:
Scenes of the Night.* New York: Harry N. Abrams,
1994.

Hagen, Rose-Marie & Hagen, Rainer.
What Great Paintings Say. Cologne: Taschen, 2000.

Hoog, Michel. *Cézanne: Father of 20th-Century Art.*
New York: Harry N. Abrams, 1994.

Howard, Michael. *Gauguin.* London: Dorling
Kindersley, 1992.

Nonhoff, Nicola. *Paul Cézanne: Life and Work.*
Cologne: Könemann, 1999.

Shaffner, Ingrid. *The Essential Vincent Van Gogh.*
New York: Harry N. Abrams, 1998.

Strickland, Carol. *The Annotated Mona Lisa: A Crash
Course in Art History from Prehistoric to Post-modern.*
Kansas City: Andrews and McMeel, 1992.

Sturgis, Alexander & Clayson, Hollis, ed.
*Understanding Paintings: Themes in Art Explored and
Explained.* New York: Watson-Guptill, 2000.

Torterolo, Anna. *ArtBook Van Gogh.* London: Dorling
Kindersley, 1999.

Wiggins, Colin. *Post-Impressionism.* London: Dorling
Kindersley, 1993.

Breunesse, Caroline. *Visiting Vincent Van Gogh.*
Munich: Prestel, 1997.

Cumming, Robert. *Great Artists: The Lives of 50 Painters
Explored Through Their Work.* New York: Dorling
Kindersley, 1998.

de Bie, Ceciel and Leenen, Martijn. *Vincent van Gogh:
See and Do Children's Book.* Amsterdam: Van Gogh
Museum, 1998.

Greenfeld, Howard. *Paul Gauguin.* New York: Harry N.
Abrams, 1993.

Harrison, Peter. *Vincent Van Gogh.* New York: Sterling,
1996.

Krull, Kathleen. *Lives of the Artists: Masterpieces, Messes
(and What the Neighbors Thought).* San Diego:
Harcourt Brace, 1995.

Mühlberger, Richard. *What Makes a Van Gogh a Van
Gogh?* New York: Viking/The Metropolitan Museum
of Art, 1993.

Pfleger, Susanne. *Henri Rousseau: A Jungle Expedition.*
Munich: Prestel, 1998.

Richardson, Joy. *Looking at Pictures: An Introduction to
Art for Young People.* New York: Harry N. Abrams,
1997.

Spence, David. *Gauguin: Escape to Eden.* Tonbridge,
UK: Ticktock, 1998.

Spence, David. *Van Gogh: Art and Emotion.* Tonbridge,
UK: Ticktock, 1997.

Venezia, Mike. *Henri de Toulouse-Lautrec.* Chicago:
Children's Press, 1994.

Our thanks to the museums and galleries that exhibit the works of art featured in this book.

ART INSTITUTE OF CHICAGO

A *Sunday Afternoon on the Island of La Grande Jatte*, Georges Seurat

At the Moulin Rouge, Henri de Toulouse-Lautrec

Trick Rider at the Fernando Circus, Henri de Toulouse-Lautrec

BALTIMORE MUSEUM OF ART

Mont Sainte-Victoire Seen From the Bibémus Quarry, Paul Cézanne

CLARK ART INSTITUTE
Williamstown, Massachusetts

At the Circus: Chocolat, Henri de Toulouse-Lautrec

HUNTINGTON ART GALLERY
San Marino, California

Breakfast in Bed, Mary Cassatt

KIMBELL ART MUSEUM Fort Worth, Texas

Saint Sebastian Attended by Saint Irene, Georges de La Tour

THE METROPOLITAN MUSEUM OF ART New York

Circus Sideshow, Georges Seurat

The Gulf of Marseille Seen from L'Estaque, Paul Cézanne

Madame Cézanne in the Conservatory, Paul Cézanne

MUSÉE DU VIEUX CHATEAU Laval, Quebec

Le Douanier Rousseau, Robert Delaunay

MUSEUM OF FINE ARTS, BOSTON

Madame Cézanne in a Red Armchair, Paul Cézanne

MUSEUM OF MODERN ART New York

Port-en-Bessin, Entrance to the Harbor, Georges Seurat

The Persistence of Memory, Salvador Dali

The Sleeping Gypsy, Henri Rousseau

The Starry Night, Vincent Van Gogh

Still Life with Three Puppies, Paul Gauguin

NATIONAL GALLERY OF ART Washington, D.C.

Breton Girls Dancing, Pont-Aven, Paul Gauguin

The Jockey, Henri de Toulouse-Lautrec

The Pont Neuf, Paris, Auguste Renoir

Self-portrait, Paul Gauguin

PHILADELPHIA MUSEUM OF ART

A Carnival Evening, Henri Rousseau

At the Moulin Rouge: The Dance, Henri de Toulouse-Lautrec

The Railway Bridge, Argenteuil, Claude Monet

SAN DIEGO MUSEUM OF ART

The Passenger from Cabin 54, Henri de Toulouse-Lautrec

SMITH COLLEGE MUSEUM OF ART
Northampton, Massachusetts

Woman with a Monkey, Georges Seurat

ASHMOLEAN MUSEUM Oxford, England
 Peasants Planting Pea Sticks, Camille Pissarro

BIBLIOTHÈQUE NATIONALE Paris, France
 Ambassadeurs: Aristide Bruant,
 Henri de Toulouse-Lautrec

HERMITAGE MUSEUM St. Petersburg, Russia
 Red Room, Henri Matisse

KRÖLLER-MÜLLER MUSEUM
Otterlo, Netherlands
 The High Kick, Georges Seurat

LOUVRE MUSEUM Paris, France
 Liberty Guiding the People, Eugène Delacroix
 Oath of the Horatii, Jacques-Louis David
 The Silver Goblet, Jean-Baptiste-Siméon Chardin

MUSÉE D'ART MODERNE Paris, France
 Portrait of Georges Seurat, Ernest Laurent

MUSÉE DES AUGUSTINS Toulouse, France
 Portrait of Toulouse-Lautrec, Henri Rachou

MUSÉE D'ORSAY Paris, France
 Arearea (Amusement), Paul Gauguin
 The Bedroom, Vincent Van Gogh
 The Card Players, Paul Cézanne
 The Circus, Georges Seurat
 Dancing at the Moulin de la Galette, Auguste Renoir
 Grain Stacks, End of Summer, Claude Monet
 Idol with a Pearl, Paul Gauguin
 Kitchen Table, Paul Cézanne
 The Meal (Bananas), Paul Gauguin
 Noontime, Rest from Work, Vincent Van Gogh
 Regattas at Argenteuil, Claude Monet
 The Snake Charmer, Henri Rousseau
 War, Henri Rousseau
 The White Horse, Paul Gauguin

MUSÉE MARMOTTAN Paris, France
 Impression, Sunrise, Claude Monet

MUSÉE PICASSO Paris, France
 Still Life with Chair Caning, Pablo Picasso

NASJONALGALLERIET Oslo, Norway
 The Scream, Edvard Munch

NATIONAL GALLERY Prague, Czechoslovakia
 Myself, Portrait-Landscape, Henri Rousseau

NATIONAL GALLERY OF ART London, England
 Bathers at Asnières, Georges Seurat
 Surprise! (Tiger in a Tropical Storm), Henri Rousseau

NATIONAL GALLERY OF SCOTLAND Edinburgh
 The Vision after the Sermon, Paul Gauguin

ÖSTERREICHISCH GALERIE Vienna, Austria
 The Kiss, Gustav Klimt

PUSHKIN MUSEUM Moscow, Russia
 Self-portrait, Paul Cézanne

SAARLAND MUSEUM Saarbruck, Germany
 Little Blue Horse, Franz Marc

THYSSEN-BORNEMISZA COLLECTION
Madrid, Spain
 Green Dancer, Edgar Degas

TOULOUSE-LAUTREC MUSEUM Albi, France
 Divan Japonais, Henri de Toulouse-Lautrec

VAN GOGH MUSEUM Amsterdam, Netherlands
 Fishing Boats on the Beach at Saintes-Maries,
 Vincent Van Gogh
 Irises in a Vase, Vincent Van Gogh
 Portrait of Vincent Van Gogh,
 Henri de Toulouse-Lautrec
 Quay with Ships, Vincent Van Gogh
 Self-portrait, Vincent Van Gogh
 Sketch of the Bedroom, Vincent Van Gogh
 The Yellow House, Vincent Van Gogh

Art Credits

ABBREVIATIONS AI: Archivo Iconografico **AIC**: The Art Institute of Chicago **AR**: Art Resource, New York **ARS**: Artists Rights Society, New York **B**: Bettman **BAL**: Bridgeman Art Library **BN**: Bibliothèque Nationale, Paris **C**: Corbis **EL**: Erich Lessing **G**: Giraudon **GDO**: Gianni Dagli Orti **MET**: The Metropolitan Museum of Art, New York **MFA**: Museum of Fine Arts, Boston **MoMA**: The Museum of Modern Art, New York **NGL**: The National Gallery, London **NGW**: National Gallery of Art, Washington **PC**: Private Collection **PHIL**: Philadelphia Museum of Art **RMN**: Réunion des Musées Nationaux **VGM**: Collection Vincent Van Gogh Foundation/Van Gogh Museum, Amsterdam.

Cover. Vase with Irises: VGM. Photograph of picture frame: Drew Wright, San Francisco.

2. The Pont Neuf, Paris: Ailsa Mellon Bruce Collection, © 2002 Board of Trustees, NGW. Paris subway entrance: Paul Almasy/C.

3. Machinery Hall at the 1889 Exposition: AI/C. Eiffel Tower and Grounds, 1889 Exposition: Leonard de Selva/C.

4. Dancing at the Moulin de la Galette: RMN/AR. Oath of the Horatii (Louvre): AI/C. Grain Stacks, End of Summer: EL/AR.

5. Third Class Carriage: Burstein Collection/C. Idol with a Pearl: RMN/AR. Photograph of paint tubes: Drew Wright, San Francisco.

6. Map of France: Katrin Queck, Emago.com, San Diego. Green Dancer: EL/AR. Breakfast in Bed: Huntington Library, Art Collections and Botanical Gardens, San Marino, California/Superstock. Peasants Planting Pea Sticks: Ashmolean Museum, Oxford. The Scream: Burstein Collection/C, © 2002 The Munch Museum/The Munch-Ellingsen Group/ARS.

7. Woman in a Checked Dress: PC/BAL, © 2002 ARS/ADAGP, Paris. The Kiss: Austrian Archives/C. Little Blue Horse: G/AR. Red Room: Alexander Burkatowski/C, © 2002 Succession H. Matisse, Paris/ARS. Still Life with Chair Caning: Musée Picasso, Paris/BAL, © 2002 Estate of Pablo Picasso/ARS.

8. Franco-Prussian War: GDO/C. Commodore Perry's Gift of a Railway to the Japanese by Ando or Utagawa Hiroshige: PC/BAL. Victorian Style Telephone: B/C. Queen Victoria: GDO/C. Coal miner: GDO/C. Kodak poster: B/C. People Walking Under The Eiffel Tower: Michael Maslan Historic Photographs/C. Impression, Sunrise: EL/AR. Edison's First Light Bulb: B/C. The Railway Bridge, Argenteuil, by Claude Monet: PHIL/C, © 2002 ARS/ADAGP. Statue of Liberty: Museum of the City of New York/C. Cowboy: B/C. Sarah Bernhardt poster: AI/C.

9. Bicyclists: B/C. Poster for Debussy's Pelléas et Mélisande: GDO/C. The Traitor: The Degradation of Alfred Dreyfus: PC/BAL. Sigmund Freud: B/C. Wright Brothers: B/C. Ford Model T: B/C. Admiral Robert Peary: B/C. Cinematographe Lumière poster: PC/Archives Charmet/BAL. Nobel Prize medal: B/C. Marie Curie: B/C. Boer War: AI/C. Albert Einstein in 1931: B/C. Panama Canal: B/C. W.H. Auden I Poster: C.

10. Self-portrait, Paul Cézanne: G/AR. Portrait of Georges Seurat by Ernest Laurent: RMN/AR. Self-portrait, Paul Gauguin: Collection of Mr. and Mrs. Paul Mellon, © 2002 Board of Trustees, NGW.

11. Self-portrait, Vincent Van Gogh: VGM. Le Douanier Rousseau, by Robert Delaunay, 1914: G/AR, © L & M Services B.V. Amsterdam 20020517. Portrait of Toulouse-Lautrec, by Henri Rachou: Musée des Augustins, Toulouse. Photograph: Bernard Delorme.

12-13. Still Life with Fruit Dish: Private collection. Photo by Malcolm Varon, NYC © 2002.

14-15. Regattas at Argenteuil: RMN/AR. The Gulf of Marseille: MET, H.O. Havemeyer Collection, Bequest of Mrs. H.O. Havemeyer, 1929 (29.100.67) Photograph © 1979 MET.

16-17. The Silver Goblet: RMN/AR. Kitchen Table: RMN/AR.

18. Madame Cézanne in a Red Armchair: Courtesy, MFA. Bequest of Robert Treat Paine 2nd (44.776). Reproduced with permission. © MFA. All Rights Reserved.

19,1. Madame Cézanne in the Conservatory: MET, Bequest of Stephen C. Clark, 1960. (61.101.2) Photograph © 1980 MET.

20-21. The Card Players: EL/AR. Drawing based on The Card Players: Diana Howard, San Francisco.

22-23. Mont Sainte-Victoire Seen from the Bibémus Quarry: The Baltimore Museum of Art: The Cone Collection, formed by Dr. Claribel Cone and Miss Etta Cone of Baltimore, Maryland BMA1950.196.

24-25. Bathers at Asnières: © NGL.

26-27. Woman with a Monkey: Smith College Museum of Art, Northampton, Mass. Purchased, Tryon Fund, 1934. A Sunday Afternoon on the Island of La Grande Jatte: Helen Birch Bartlett Memorial Collection, 1926.224 © AIC. All Rights Reserved.

28-29. Port-en-Bessin, Entrance to the Harbor: MoMA. Lillie P. Bliss Collection. Photograph © 2002, MoMA.

30-31. Circus Sideshow: MET, Bequest of Stephen C. Clark, 1960. (61.101.17) Photograph ©1989 MET.

32-33. Servants Presenting Themselves to the Master: GDO/C. The High Kick: EL/AR.

35,1. The Circus: EL/AR

36-37. Breton Girls Dancing, Pont-Aven: Collection of Mr. and Mrs. Paul Mellon, © 2002 Board of Trustees, NGW.

38-39. Leda and the Swan: PC/Christie's Images/BAL. Still Life with Three Puppies: MoMA. Mrs. Simon Guggenheim Fund. Photograph © 2001, MoMA.

40-41. Annunciation: Dean Conger/C. The Vision after the Sermon: The National Gallery of Scotland, Edinburgh/BAL

42. The Meal (Bananas): RMN/AR.

44-45. Arearea (Amusement): RMN/AR.

47. The White Horse: RMN/AR.

48-49. Fishing Boats on the Beach at Saintes-Maries: VGM. Quay with Ships: VGM.

50-51,v. The Yellow House: VGM. Vase with Irises: VGM.

53. The Bedroom: EL/AR. Sketch of the Bedroom: VGM.

56-57. The Starry Night: MoMA. Acquired through the Lillie P. Bliss bequest. Photograph © 2001, MoMA.

58-59. Noontime, Rest from Work: EL/AR.

61,1. A Carnival Evening: PHIL, The Louis E. Stern Collection.

62-63. Myself, Portrait-Landscape: EL/AR. Print of 1889 Exposition: GDO/C.

64-65. Surprise! (Tiger in a Tropical Storm): © NGL.

66-67. War: RMN/AR. Liberty Guiding the People: G/AR.

68-69. The Persistence of Memory, 1931, oil on canvas, 23 x 33 cm, given anonymously: MoMA/Scala/AR, © 2002 Salvador Dali, Gala-Salvador Dali Foundation/ARS. The Sleeping Gypsy: MoMA. Gift of Mrs. Simon Guggenheim. Photograph © 2001, MoMA.

71. The Snake Charmer: RMN/AR.

72-73. Trick Rider at the Fernando Circus: Joseph Winterbotham Collection, 1925.523 © AIC. All Rights Reserved. At the Circus: Chocolat: © 1991 Clark Art Institute.

74-75. At the Moulin Rouge: The Dance: PHIL, The Henry P. McIlhenny Collection in memory of Frances P. McIlhenny.

76, iv. Portrait of Van Gogh: VGM.

77. Ambassadeurs: Aristide Bruant: BN/BAL.

78-79. Saint Sebastian Attended by Saint Irene: Kimbell Art Museum/C. At the Moulin Rouge: Helen Birch Bartlett Memorial Collection, 1928.610 © AIC. All Rights Reserved.

80-81. The Passenger from Cabin 54: San Diego Museum of Art, U.S.A./Gift of the Baldwin M. Baldwin Foundation/BAL. Divan Japonais: EL/AR.

83. The Jockey: Rosenwald Collection, © 2002 Board of Trustees, NGW.

Parents' Choice Gold Medal
ForeWord Magazine Editor's Choice

Parents' Choice Gold Medal

Birdcage Art Games & Books

Birdcage Books' award-winning art games have been acclaimed by educators as the
most effective educational art games on the market.
Each game brings great artists alive through two favorite card games
and a full-color art book (also sold separately).
Birdcage art books and games are available at bookstores, gift shops and
museum stores everywhere, and online at
www.BirdcageBooks.com

"The perfect combination of education and entertainment."
— *ForeWord Magazine*